Klee

Great Modern Masters

Klee

General Editor: José María Faerna

Translated from the Spanish by Alberto Curotto

CAMEO/ABRAMS

HARRY N. ABRAMS, INC., PUBLISHERS

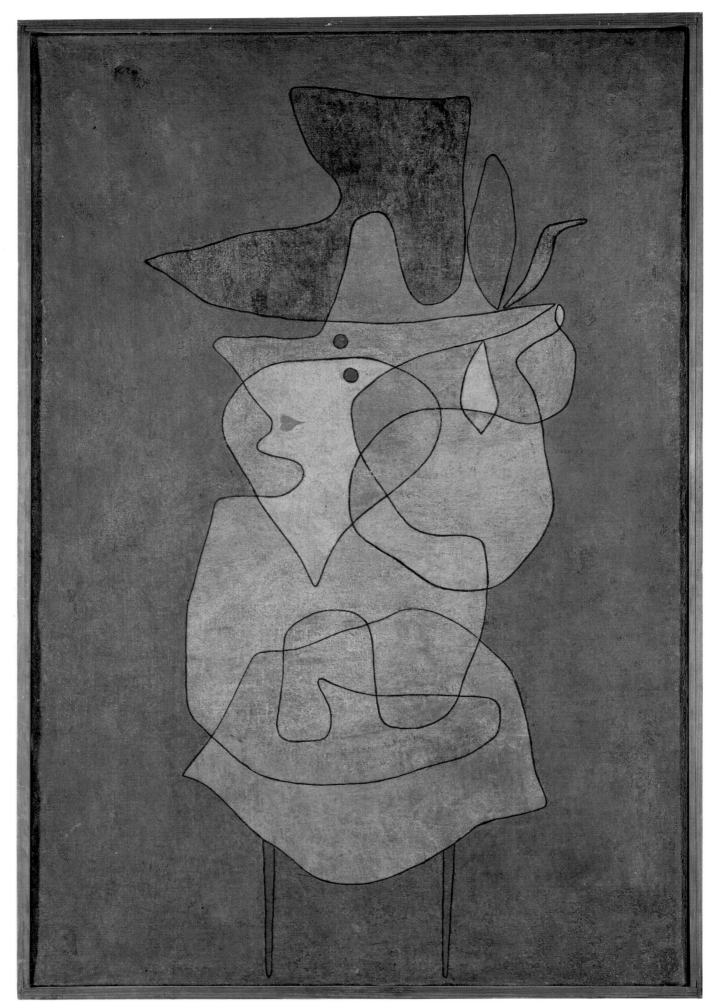

Demon-Lady, *1935. Oil and watercolor on gessoed burlap, 59¼ × 39½" (150.5 × 100 cm). Klee Foundation, Kunstmuseum, Bern.*

Paul Klee's Parallel Universe

Although he is one of the important figures of twentieth-century art, Paul Klee has always been difficult to define stylistically. This is true despite the fact that for most of his career he was fully involved in the avant-garde. During his formative years, he benefited from his participation in the dynamic artistic life that flourished in Munich during the first years of the century. There he was involved, although in a minor way, in the group of expressionist painters called Der Blaue Reiter (The Blue Rider), which had been formed in Munich by Wassily Kandinsky and Franz Marc. Later Klee taught for ten years at the Bauhaus, the art school founded in 1919 by the architect Walter Gropius to bring the avant-garde and the industrial world closer together.

Experience and Nature

In fact, Klee was associated with every Modernist artistic movement that emerged in the German-speaking world. Yet his work is unyieldingly unique. "Here below, I am not to be grasped at all," Klee wrote in his journal, beginning a famous paragraph that his son was later to have engraved on the artist's tombstone. Indeed, as this statement suggests, his art lies beyond the pale of objective representation, within the spiritual realm theorized by Kandinsky and others, from which abstraction arose. Klee, however, only partially followed in the steps of those artists. His painting is never fully abstract, not only because it frequently contains representational elements—people, objects, trees, ideograms—but also because of its links with the sensory experience of nature, which the artist never renounced. By 1905, Klee had already decided that "the object per se is certainly dead." However, he was equally firm that "the sensation caused by the object" was not. What Klee does share with Kandinsky and his circle is the central concern of all modern art: a belief in the autonomy of art from the rules that govern the natural world. While the Cubists viewed this independence as essential for painting to produce a thoroughly rigorous representation of the physical world, Kandinsky and other artists influenced by theosophy and spiritualism saw it as a means to enter an indefinite celestial universe.

A Transcendent Art

Klee stood between these two positions. For him, painting was a language which provided a bridge between "external vision" and "internal contemplation." He believed that the sensation of seeing belonged as much to the perceived object as to the eye seeing it. Although sensory experience was the raw material of art, painting presupposed an order of things unlike that of nature, over which art exerted a revelatory and transcendent

Self-Portrait, *1899. The artist's early work was almost entirely drawing and etching.*

Aquarius as a Fetishist, *1907. Many of Klee's early works depict grotesque figures animated by a burlesque or expressionistic spirit.*

Virgin in a Tree, *1903. One of the earliest of the etchings from Klee's* Inventions *series, which he produced between 1903 and 1906.*

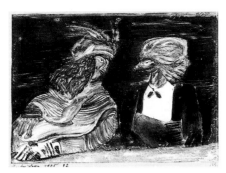

Gentleman and Lady in a Theater Box, *1908. With works such as this, painted on the back of glass coated with white tempera and then engraved, Klee increasingly distanced himself from the marked linearity of his early drawings.*

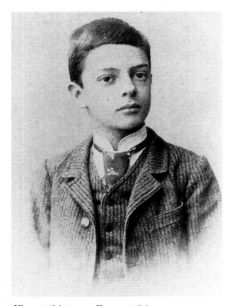

Klee at thirteen. *Even at this young age, the future painter was already an accomplished violinist, and his parents hoped that he would become a professional musician.*

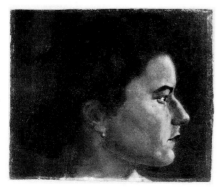

The Artist's Sister, *1903. Oil and watercolor on cardboard, 10¹³⁄₁₆ × 12⁵⁄₁₆" (27.5 × 31.5 cm). Mathilde, three years Paul's senior, was the painter's only sister.*

power. In Klee's words, "Art does not reproduce the visible; it makes the visible."

The Discovery of Color

For Klee, painting partook of nature, but also of fantasy, psychology, and even anthropology. While Kandinsky and other pioneers of abstraction refer constantly to an indefinite spiritual world of a mystic and religious nature, Klee's art reflects a broad variety of expression, including the lyrical, the poetic, and even the humorous. His range is wider than that of any painter using a related pictorial idiom, and his work embraces modes of expression that had seemed to be closed to nonobjective painting. An example of this breadth is his important reflection on the relation between the individual and power expressed by the five works on bridges and viaducts that he painted in 1937.

Like many other German artists, Klee suffered from the cultural policies of the Nazis, who forced him from his teaching post at the Academy of Düsseldorf, confiscated over one hundred of his paintings and drawings from various German museums, and included seventeen others in the exhibition *Degenerate Art,* where one of his works was compared to a drawing made by a schizophrenic patient. Although Klee tried to live in an elevated sphere, he lived at a time when the direct force of social and political circumstance could not be escaped.

Klee never formally codified his pictorial language, but his description of the working of its components was explicit. His painted surfaces represent a topography of sensation and meaning; the paintings themselves are maps of an invisible universe constructed with visible elements. Color, the primary vehicle to express feeling, is the most important of these, as Klee discovered for his own purposes while painting in Tunis in 1914. Color was to give his painting structure. Indeed, most of Klee's works from before his visit to Tunis are essays in light and shade. Most of these are in watercolor, whose blended and gauzy effects he preferred to the more vivid and saturated colors of oil, which the majority of German expressionists before World War I had adopted from the French fauvists. Klee, however, found watercolor a better vehicle for his coloristic explorations of light and space.

Plastic Richness

Line, too, was crucial to Klee's art, expressing both movement and tension on his painted surfaces. Especially important to his work is the idea of time, that things occur successively rather than simultaneously. Line also creates shapes, some specifically representational—such as those of people and objects—and others ideographic. An example of the latter given by the artist himself was that of a surface crossed by lines, which subliminally suggest the furrows of a plowed field. Klee's ideographic imagination dominates the pictograms and hieroglyphs of his last years, integrating his early training as a draftsman and engraver into his mature pictorial language. The result is one of the richest and most singular bodies of work of the twentieth century, and one that, by delineating an inimitable universe, distinct from and parallel to the world of experience, has helped shape the course of modern art.

Paul Klee/1879–1940

Despite the fact that he was born in the canton of Bern, and that in his last years he requested and was granted Swiss citizenship, Paul Klee was German. So was his father, Hans Klee, a musician and professor in the Bern public school system in Hofwil, where he had moved after marrying a singing student from Basel. The tradition of musicianship in Klee's family strongly influenced the formation of the young man's character. Paul Klee started playing the violin when he was seven, and at eleven was already a member of the Bern Music Society. In some respects, his painting and drawing represented a liberation from formidable family tradition. It is interesting that although Klee was an excellent violinist, and continued to play the instrument throughout his life, he was never interested in the musical avant-garde epitomized by Arnold Schönberg, whom he met in Munich, nor in the associations of music and painting that were so important to some of the artists close to him, such as Kandinsky.

Munich, Italy, Paris

Klee's artistic biography begins in Munich, where in 1898 he began to study painting. Two years later, he was attending Franz von Stuck's class at the Munich Academy and dividing his time between the Bavarian capital and his family home in Bern. During these years, he traveled to Italy and Paris, in order to broaden his knowledge of both ancient and modern art. In 1906, he married Lily Stumpf, a pianist whom he had met seven years earlier, during his first years as a student. By 1906, Klee was immersed in the artistic life of Munich, where every contemporary current was flourishing, including *Jugendstil*, the German variant of Art Nouveau. Indeed, the influence of *Jugendstil* can be seen in the markedly linear emphasis of the artist's early works, including etchings and paintings on glass, which depict fantastic beings and figures delineated in a grotesque and expressionistic manner.

1914: A New Path

In 1911, Klee came into contact with August Macke and Wassily Kandinsky, who with Franz Marc had founded the group known as *Der Blaue Reiter*, or The Blue Rider. This milieu was to encourage Kandinsky's movement toward abstraction, but Klee's involvement in the group, owing to his youth and relative artistic immaturity, was more limited than that of his colleagues. His works were shown only in the group's second exhibition, in 1912, and his only contribution to the celebrated almanac, published by the group the same year, was a single drawing. Klee did not fully emerge as a painter until 1914, when he took a short trip to Tunis with his friends Louis Moilliet and August Macke. In Tunis, he learned how to construct a painting from color, moving beyond the essentially graphic manner in which he had worked until that time.

World War I had surprisingly little impact on Klee's career. Although he was drafted into the army, he was not actually called for service until 1916, and even then he was not sent into combat. Moreover, his painting began to enjoy some commercial success during the war years. Tragically, how-

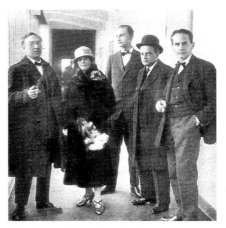

Wassily and Nina Kandinsky, Georg Muche, Paul Klee, and Walter Gropius in 1926, the year the new Bauhaus opened in Dessau.

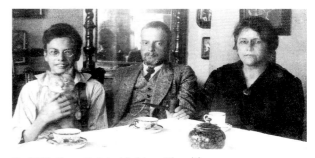

In 1921, the artist decided to settle with his family in Weimar, where the Bauhaus was originally based. This photograph, in which the painter is seen between his sister Mathilde and his son Felix, was taken at around that time.

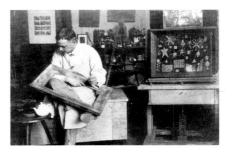

The artist at work in his studio at the Bauhaus in Weimar, in 1924. That same year, the city government closed down the school, which consequently moved to Dessau.

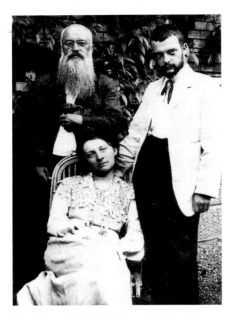

Paul Klee with his father and his wife, the pianist Lily Stumpf, the year of his marriage to her in Bern, on September 15, 1906.

ever, his friends Franz Marc and August Macke were both killed at the front.

The Years at the Bauhaus

After the war, Klee was active in the Artists' Council of the short-lived Communist republic that was proclaimed in Bavaria, which brought him in contact with a number of theorists who believed that modern artists should be closely involved in the training of the artisans who made everyday utilitarian objects. Not surprisingly, therefore, in 1920 he accepted an offer to teach at the Bauhaus, with which he was affiliated until 1930, first in Weimar and later in Dessau. At the Bauhaus, Klee renewed and deepened his association with Kandinsky, and also became acquainted with Alexander Jawlensky. The three of them, along with Lyonel Feininger, occasionally exhibited their work together under the label of The Blue Four. During Klee's years at the Bauhaus he developed a more systematic use of his poetic language. At the same time, his position at the school brought him into contact with a number of important figures in Europe's avant-garde.

Klee always devoted the greater part of his energies to painting rather than teaching, and this eventually caused some friction at the Bauhaus. As a result, he accepted an offer of a more conventional professorship in Düsseldorf in 1931. Unfortunately, however, the influence of Nazism was beginning to be felt in the German university system. Only two years after his appointment at Düsseldorf, Klee was denounced as a "Jewish artist" and dismissed from his post by the Nazi authorities. This marked the beginning of a period in which Klee was hounded mercilessly; his former apartment in Dessau was searched, and all of his works in German museums were withdrawn from exhibition. His dealer, Alfred Flechtheim, also a Jew, was forced to rescind his contract with Klee. From that time on, Klee's work was handled by D. H. Kahnweiler, the German art dealer working in Paris, who, some years before, had so successfully promoted the Cubist works of Picasso and Braque. Klee and his family finally fled to Bern, but even there the artist's opportunities were few. Both the defamation of the Nazis and his reputation as a radical artist made Swiss citizenship difficult to secure. The burdensome procedure for this was not entirely complete even at the time of his death in 1940.

A Struggle Against Illness

In 1936, Klee was diagnosed with scleroderma, a degenerative disease that was to kill him within a few years. Given the precariousness of his health, his artistic output continued at a surprising rate. Although some of his works refer to the tensions of the times, most of his paintings of this period are fusions of color and line in distinctive pictograms, somewhat reminiscent of hieroglyphs. Meanwhile, the situation in Germany was deteriorating. Although Klee's work was well received in France, England, and the United States, the Nazis included a number of his paintings and drawings in the 1937 exhibition *Degenerate Art*. The last four years of his life were marked by a constant struggle, both against bureaucratic difficulties and against the relentless march of his illness, which finally took his life in a Locarno clinic in 1940. His ashes were laid to rest in the cemetery of Bern, his birthplace, after his wife's death six years later.

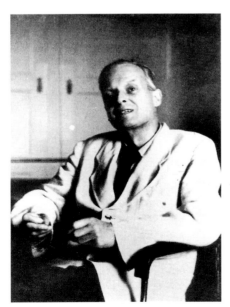

One of the last photographs of the painter, shortly before his death. Two important retrospectives, in New York and Bern, would subsequently honor the artist's memory.

Plates

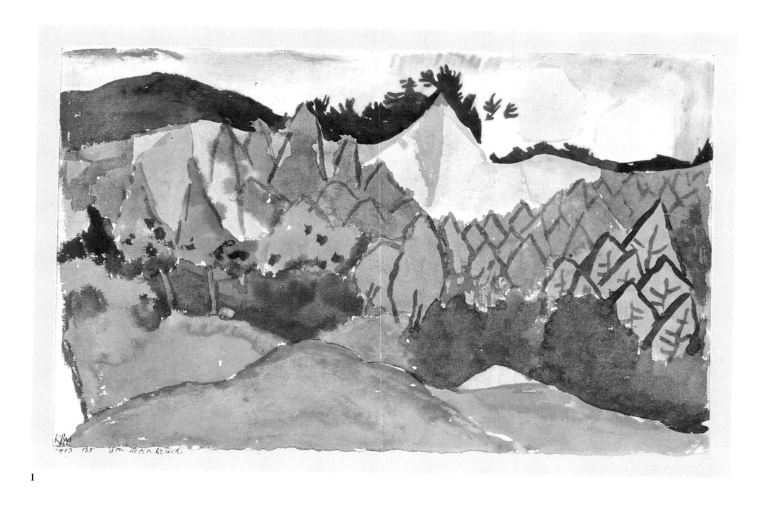

1

Early Works

Until 1914, Klee's work was almost entirely drawings and prints. Most of the pieces that he exhibited in the Munich Secession shows of 1906 and 1908 were etchings from a group which he called *Inventions*, executed between 1903 and 1906. In 1907, however, he started experimenting with watercolor. His work in this new medium focused on problems of light and shading, and on the representation of volume. Thus Klee was already attuned to one of the central preoccupations of Modernism at this period: the use of color as a primary structural element in painting. Although he never saw Cézanne's work until his second trip to Paris in 1912, Klee aspired, in his own distinct manner, to much the same goals as the French painter. While Cézanne strove for structural solidity with an Impressionist's fragmented brush stroke, Klee experimented with large planes of softly modulated color, full of suggestions of space. His preference for the watercolor medium and for a small format, both typical of his entire output, was thus evident even at the beginning of his career.

1 In the Quarry, *1913. The understated palette in this work differentiates the lighted areas from the shaded ones, as in the mountain peak in the middle. The higher color density along the edges of the planes seems to contain the potential energy of the vibrant violets and oranges.*

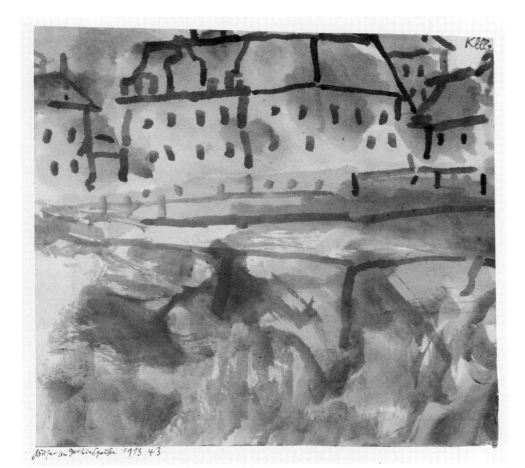

2 Houses near Stony Ground, *1913. This quick sketch is an example of the artist's methodical progress in his works before 1914 toward a painterly expression.*

3 Quarry at Ostermundigen: Two Cranes, *1907. The quarry theme recurs in several of Klee's early drawings and paintings, possibly because the blocks of stone provided clear-cut volumes that could be represented as isolated surfaces of color. The almost monochromatic palette—muted variations of blue, green, and brown— testifies to Klee's interest in chiaroscuro in his early years.*

2

3

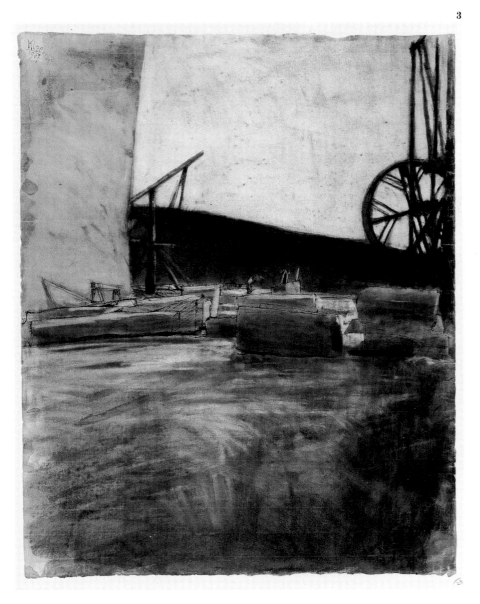

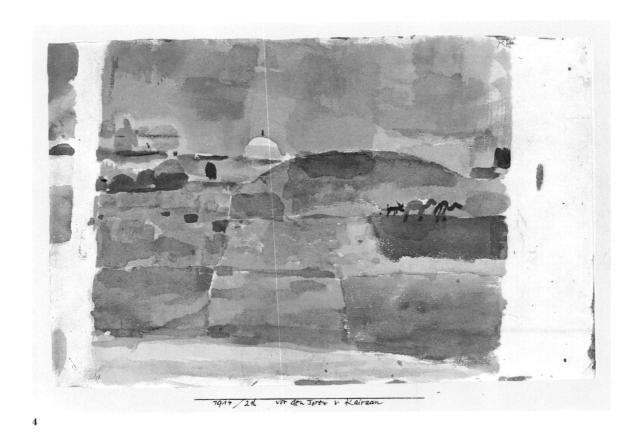

4

The Discovery of Color

On April 7, 1914, Klee disembarked in Tunis, accompanied by August Macke and Louis Moilliet, an artist friend from Bern who had introduced him to Kandinsky and The Blue Rider group. Despite the brevity of his stay—he sailed back to Europe less than two weeks later, on April 19— Klee's visit to Tunis was an initiation, a time when he not only "discovered" color, but discovered himself as a painter as well. On April 16 he wrote in his diary, "I am possessed by color. It has seized me for good, I know. Such is the meaning of this happy time; I am one with color. I am a painter." The dazzling sunlight and the sharp contrasts of light and shadow in North Africa were undoubtedly a revelation to Klee. However, the work of August Macke, who at this point in his career was moving in a similar artistic direction as Klee—but was perhaps slightly ahead of him—was almost certainly an influence as well. So also, almost undoubtedly, was the work of Robert Delaunay, whom Klee had met personally in Paris in 1912, and whose meticulous abstract studies of light and color Klee had seen both in The Blue Rider exhibitions and on his trip to Paris. In 1913, Klee had even translated an article by Delaunay, *About Light*, for *Der Sturm*.

4 Before the Gates of Kairouan, *1914. Painted on the same day as Klee's diary entry proclaiming his discovery of color, this view shows the city dissolving in a delicate modulation of color. Only the domes and the three horses on the right recall the specific subject of the work.*

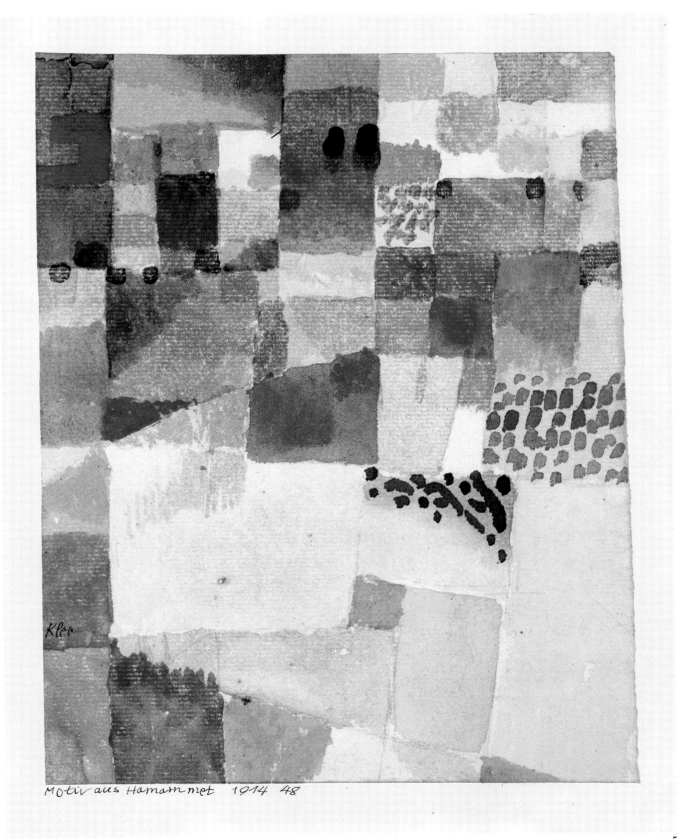

Motiv aus Hamammet 1914 48

5 Hammamet Motif, *1914. An uneven color grid
graduates a variety of tones, with the brightest ones
on the right. The degree of abstraction is greater here
than in the previous example, as though this were an
aerial view or an ideal plan.*

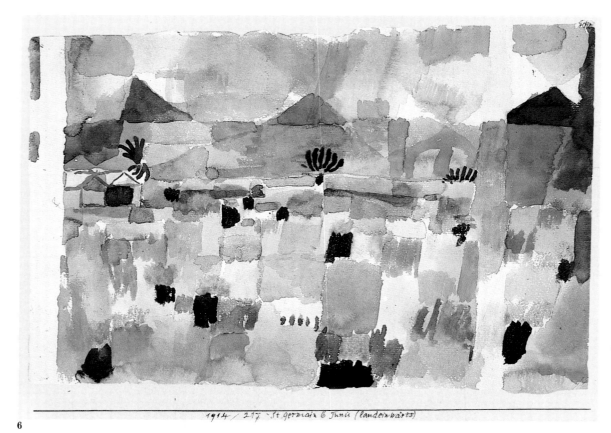

6 Saint-Germain,
near Tunis, *1914.*
Here again, the
subject is
interpreted as a
color grid, the
dominant tone
being a pinkish
twilight hue.
The schematic
suggestions of palm
trees are the sole
concession to the
local setting.

7 Quarry at
Ostermundigen,
1915. Here the artist
revisits the theme
of the quarry, this
time as an experiment
with the possibilities
of denoting the spaces
and the volumes of
the subject by
modulating the widths
and shapes of the
color blocks, as well
as the distinct
luminous vibration
of each.

6

7

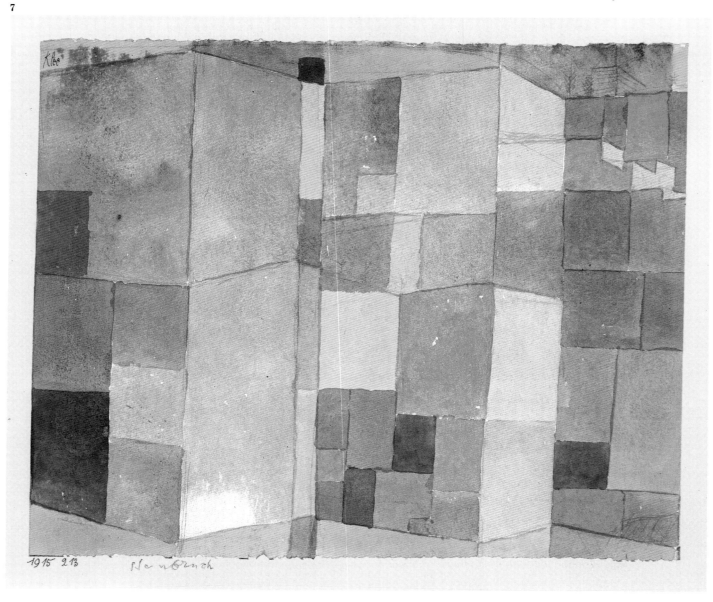

Bahn

Einst dem Grau der Nacht enttaucht / Dann schwer und teuer / und stark vom Feuer /
Abends voll von Gott und gebeugt // Nun ätherlings vom Blau umschauert, / entschwebt
über Firnen, zu klugen Gestirnen.

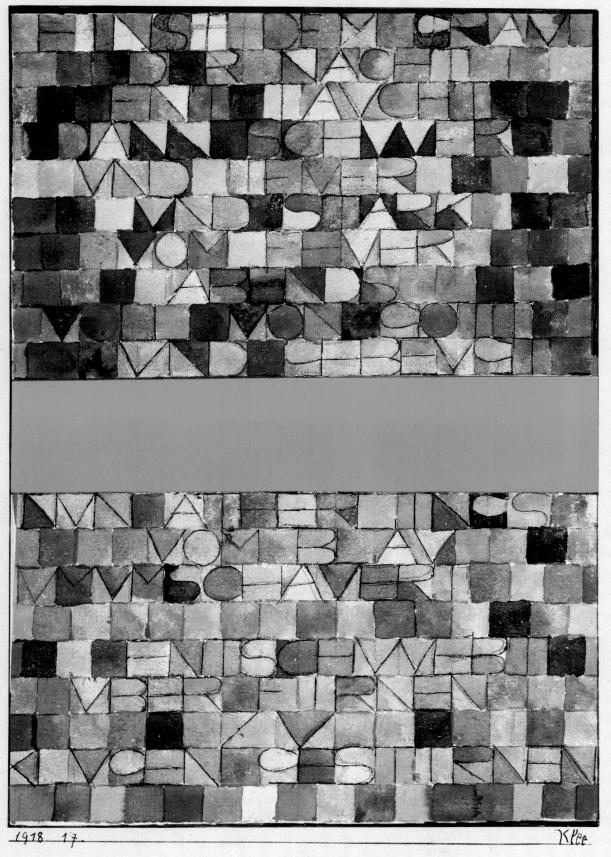

1918 17.

Klee

8 Suddenly from the Gray of Night..., 1918. A group of Chinese poems that his wife had sent him prompted
Klee to create a number of poem/paintings. This exemplifies the type, although in this case the poem, whose
letters are inscribed within brightly colored squares, was apparently composed by the painter himself.

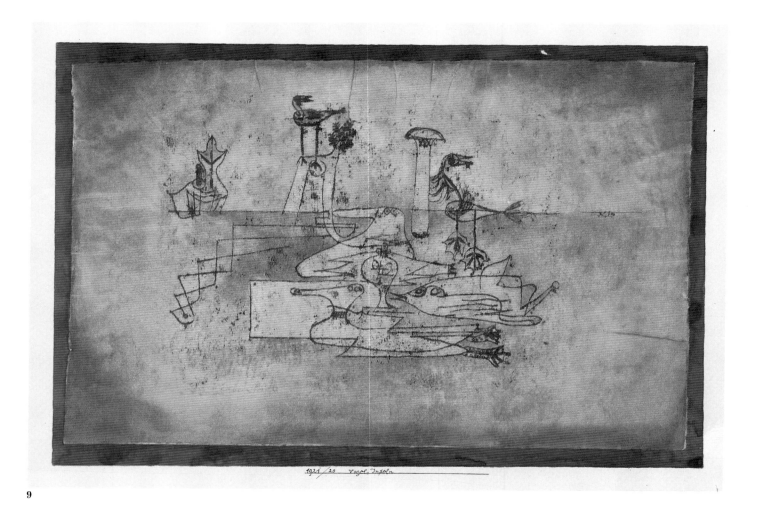

Fantastic Imagination

Although for Klee painting was essentially an abstract construction based on color, this did not preclude the presence of representational elements. Klee's initial training had been in the graphic arts, and his early etchings and drawings already exhibit the expressionistic, grotesque, and often humorous streak that would later appear in many of his paintings. While these schematic linear images define a universe of imagination and allusion, they have no narrative intent. Thus, rather than contradicting the nonobjective nature of the painting, they affirm its mediating role between the natural and the ideal worlds. At times, Klee organized his graphic motifs in a manner entirely independent of the painting's color fields. For these compositions, he customarily drew designs with an engraver's tool on the back of a piece of canvas coated with black ink, which he had placed against the picture surface. At other times, as in his many images of masks and heads, the line drawing and the color fields are closely related. Not surprisingly, Klee's idiosyncratic world of fantasy fascinated the Surrealists, in whose first Parisian exhibition of 1925 Klee participated.

9 Bird Islands, *1921. The appearance of watercolors of this type approaches that of an etching or engraving. The line drawing has been transferred to the surface by tracing on an overlying oil-primed canvas, which has been coated with ink. The finished piece markedly resembles a graphic work.*

10

10 Genie Serving a Light Breakfast, *1920. Against a bright
background, where several shades of yellow and orange are
contrasted with blue planes, the undulated rhythm of Klee's line
emphasizes his subject's ironic and humorous tone.*

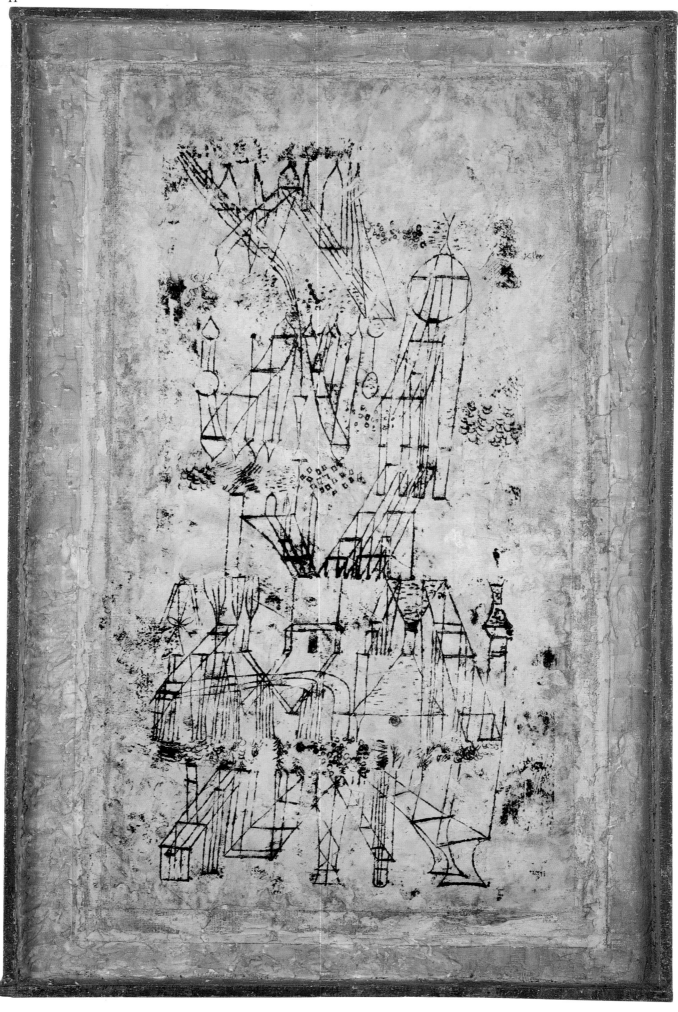

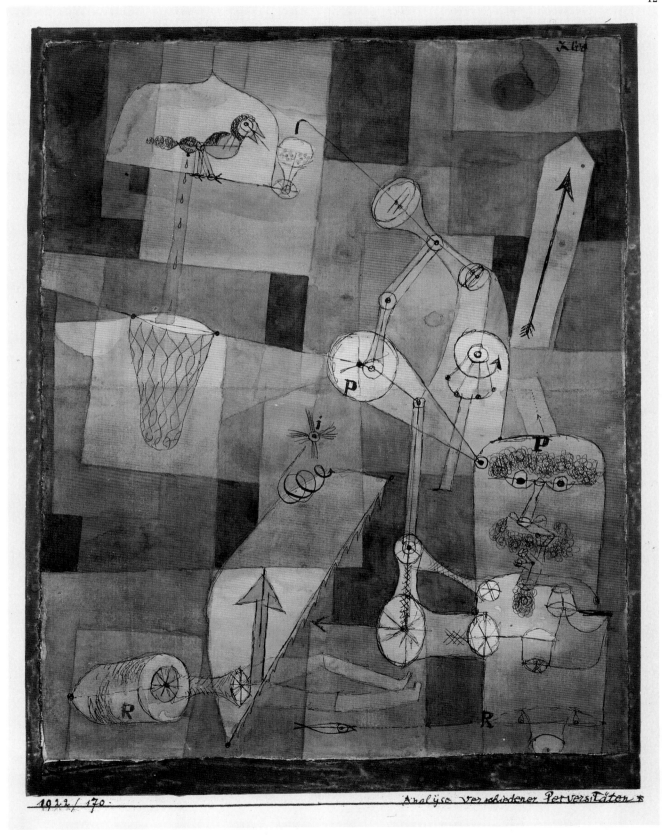

1922/170. Analyse verschiedener Perversitäten

11 Castle in the Air, *1922. The linear diagram filling the central section of this painting can be interpreted as either a plane projection or a frontal view. Klee's technique here, unusual for him, combines oil and watercolor on gessoed gauze, which gives the background a rough texture suggestive of building stone.*

12 Analysis of Various Perversities, *1922. Useless and humorous machinery was a favorite theme of the Dadaists, such as Francis Picabia. Here Klee achieves a higher degree of integration between the chromatic pattern in the background and his subject's linear pattern, although the two still do not merge completely.*

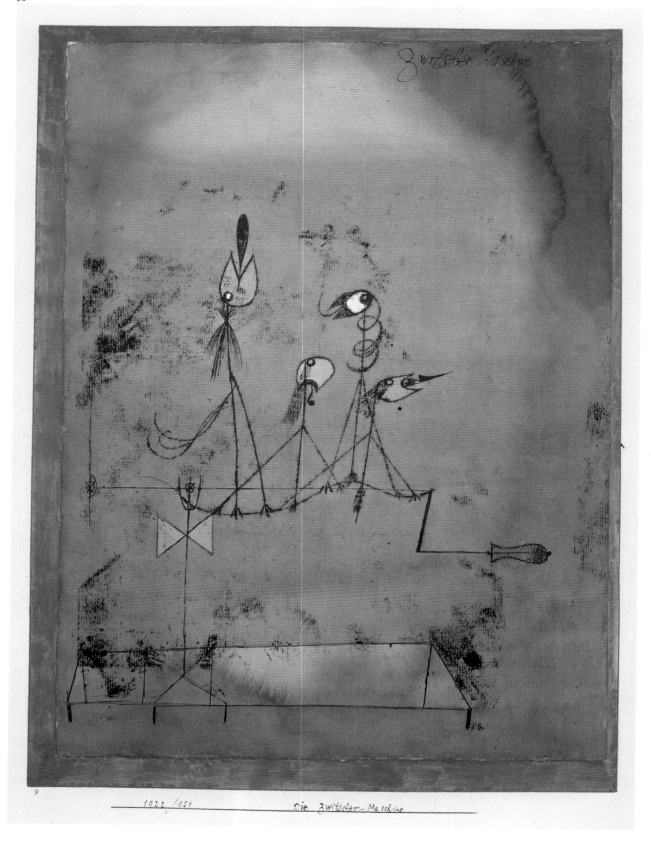

13 Twittering Machine, *1922. The lines of this quirky monotype have been traced on a watercolor background. The monotype process, with its accidental element of the stains left by the black tracing matrix, is somewhat reminiscent of Surrealist automatism. It is not surprising that Klee's painting always interested the French Surrealists greatly.*

14 Ventriloquist and Crier on the Moor, *1923. Klee's capacity to achieve poetic synthesis in his images is well exemplified here. The ventriloquist/crier at the center, pressed flat against the background color grid, carries within his body a variety of strange forms, which allude to the voices that he can imitate.*

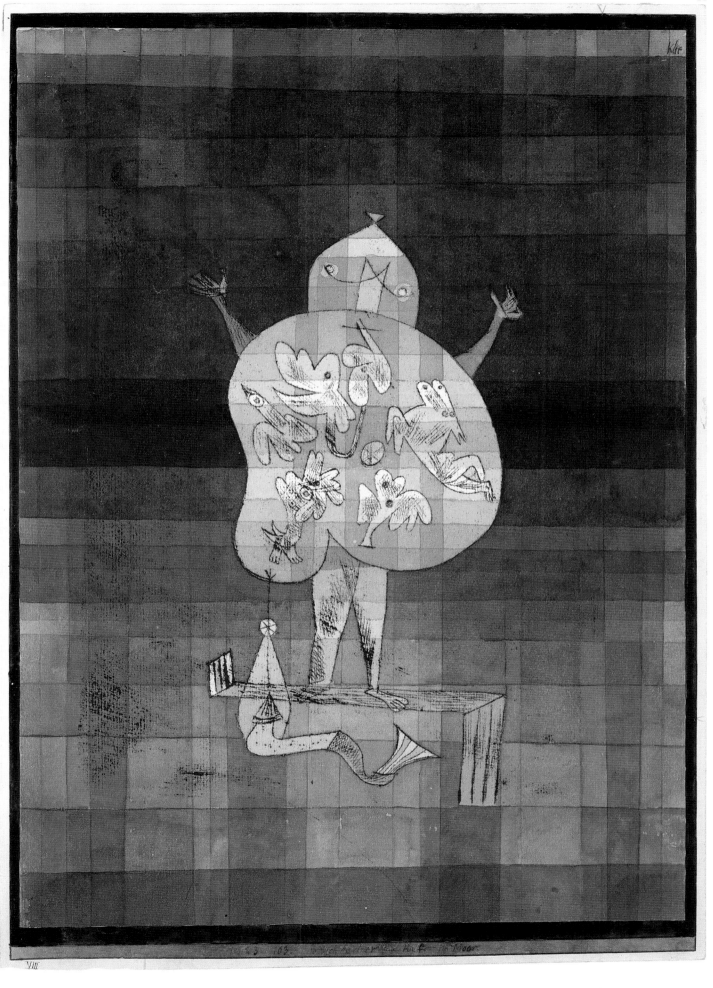

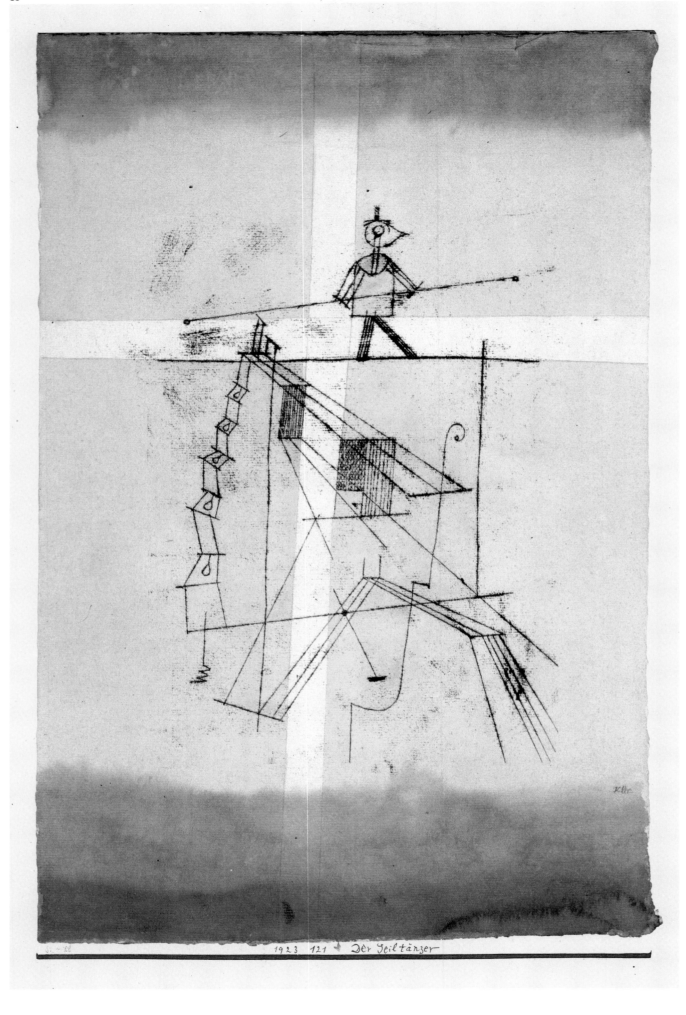

1923 121 Der Seiltänzer

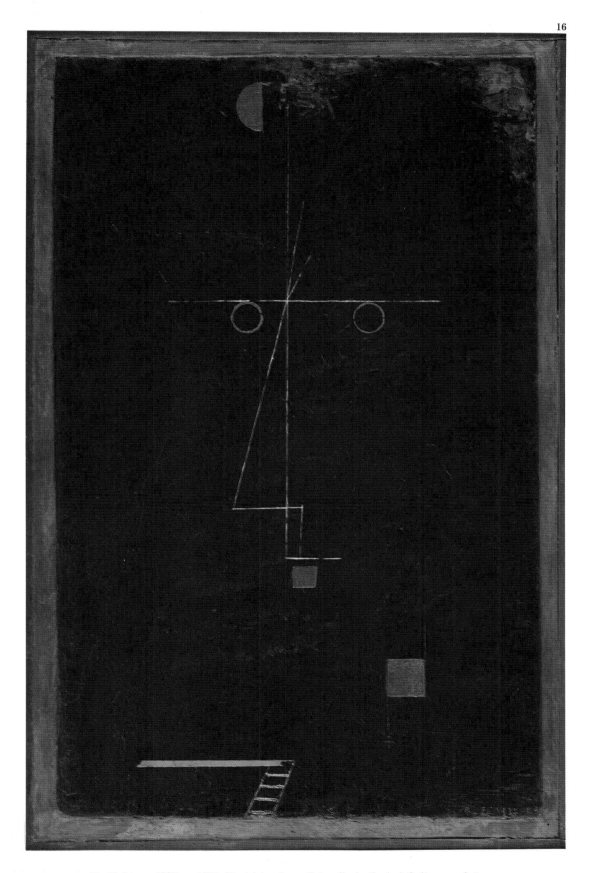

15 Tightrope Walker, *1923. The high-wire artist walks in the indefinite space between the gray areas above and below him. Perhaps this subject is a metaphor for painting, which Klee believed played a mediating role between the visible and the invisible worlds.*

16 Portrait of an Acrobat, *1927. In effect, this painting represents a mask. The lines delineating the features also suggest the swinging movement of a circus trapeze.*

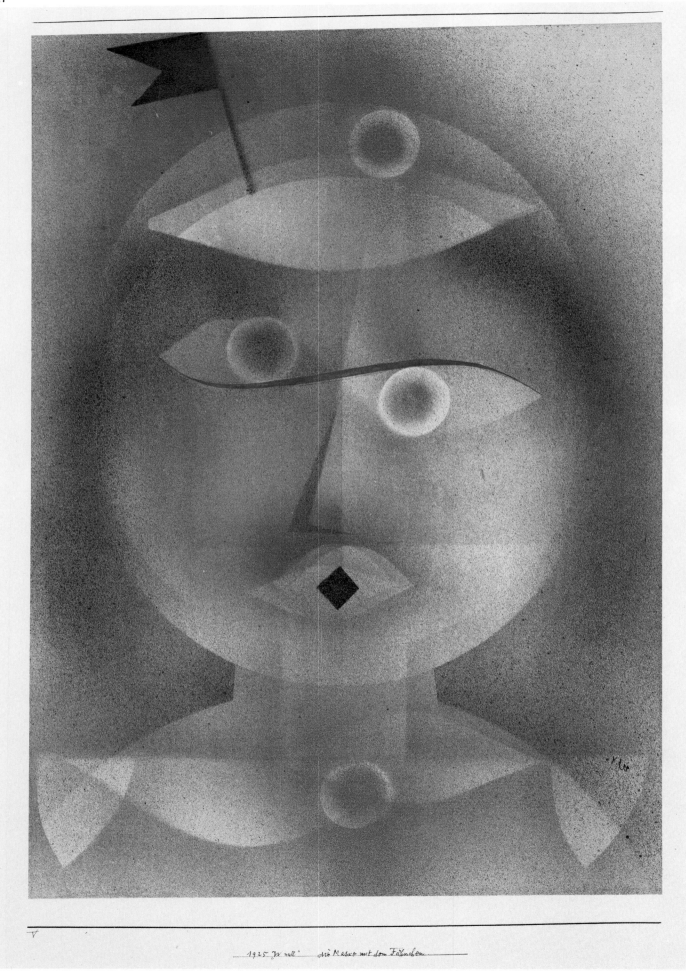

1925 W. mll. die Maske mit dem Fähnchen

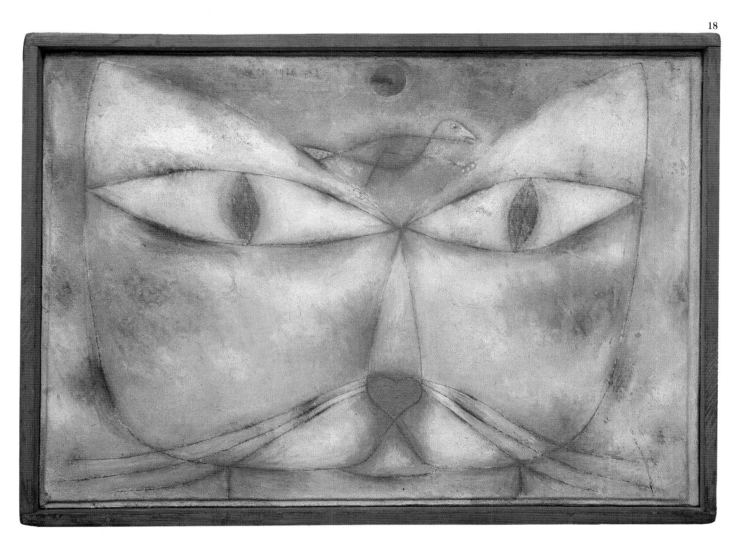

17 Mask with Banderole, *1925. In the year he painted this work, Klee produced a number of pieces of the same type, using a spray-painting technique with masking templates. These works were intended to investigate the theories of perceptive psychology of Ernst Mach and Friedrich Schumann, which Klee often discussed in his classes at the Bauhaus.*

18 Cat and Bird, *1928. The hunter's fixation on his prey is a theme that lends itself to various interpretations, political and otherwise. The soft brown hues of this work, modulated by subtle yellow and white touches, endow the extremely flat linearity of the drawing with a remarkable feeling of space.*

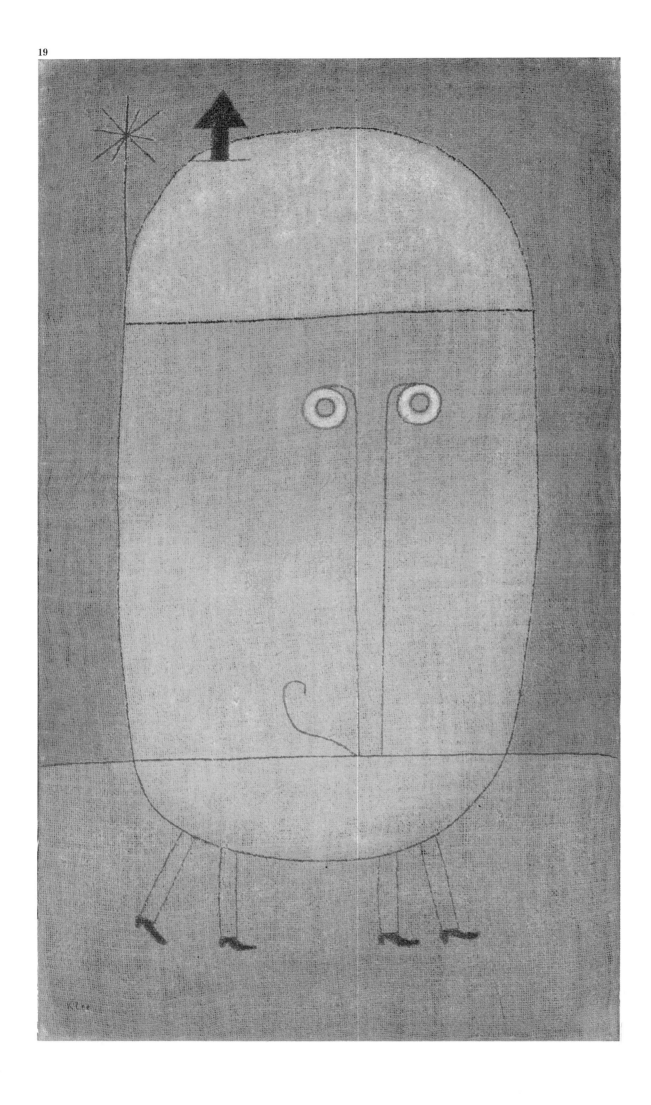

19 Mask of Fear, *1932. In this hermetic work, painted one year before the Nazis stripped him of his post at the Academy of Düsseldorf, Klee seems to be foretelling the difficult and uncertain times that he was to experience in the years to come.*

20 Oath of Ghosts, *1930. Ghosts, genies, angels, and other ethereal creatures frequently people Klee's imaginary world. Knotted skeins of lines, recalling the symbolic knots typical of Northern folk art, here depict an unlikely gathering of ghosts.*

21 In the Margin, *1930. The effect of the watercolor on the rough texture of the gessoed gauze causes the figures to appear submerged in a liquid, as if they were unrelated objects anchored in an imaginary pond.*

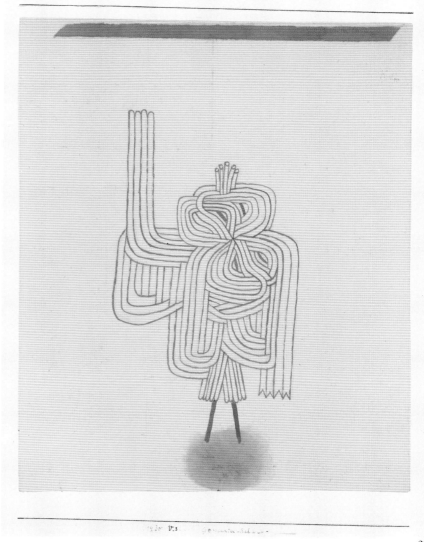

21

20

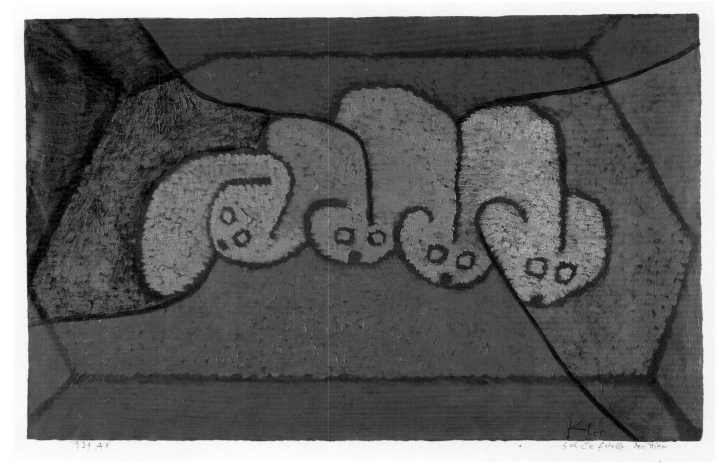

22 Shelter for Four, *1939. Painted the year before the artist's death, this work demonstrates Klee's success in integrating representational synthesis and pictorial surface. The rhythmically curving black lines outline various muted color planes, defining areas that seem to project or recede from the picture plane. The four figures, like pups snuggling together in a den for warmth, evoke a feeling of shelter and intimacy.*

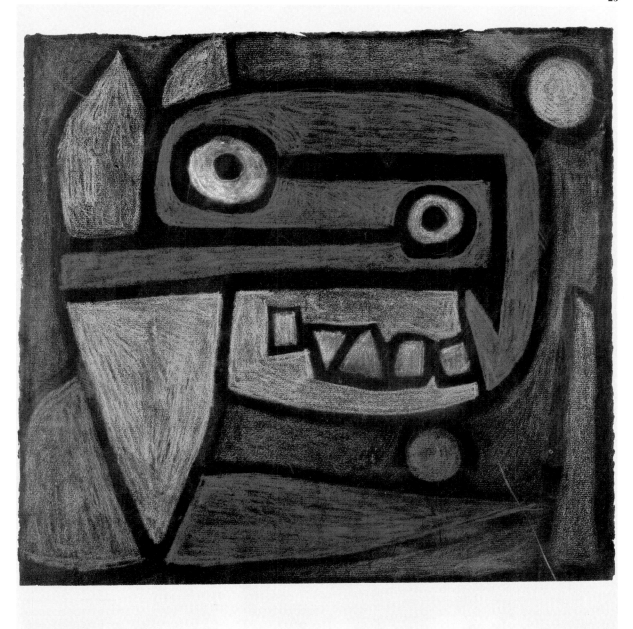

23 Untitled, *c. 1940. Here an emphatic spiral forms a monstrous face that, like most of Klee's masks, nearly fills the painted surface. This might be interpreted as an image of foreboding in anticipation of the artist's approaching death. Another painting from the same year, entitled* Death and Fire, *depicts a similar figure whose eyes are likewise misaligned.*

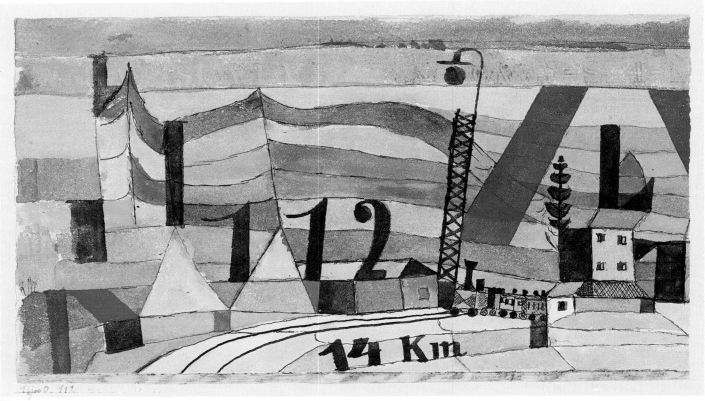

24

Form, Surface, and Color

What Klee learned in Tunis—and to which he gave expression in the works that he painted during World War I—was a technique for building a composition from patterns of color. At first, these patterns emerged from his observation and stylization of his subject's reaction to light. Later, Klee abandoned identifiable themes, and the relationship of his color patterns to his observations of nature became less direct. Such paintings were intended to represent his interior universe, a world that only he could bring to light. In these works Klee's expressive vocabulary included the interaction of colors in expanding and contracting movement on the picture's surface, arrows which pointed in various directions, and intersecting curved lines which traced mysterious trajectories that transformed the underlying color pattern. Many of these pictorial devices reflected the principals of Gestalt psychology, which Klee had studied during his Bauhaus years. Sometimes, also, he combined them with graphic or representational forms. Klee's distinctive pictorial universe is built on a complex convergence of all these elements.

24 Station L 112, 14 km., *1920. Klee has synthesized this landscape by placing both the representational elements—the train, the station, the metal tower—and the numbers and letters of the painting's name on the same level. This format recalls the poem/paintings from the final years of World War I, although here the color is organized in curved and intersecting bands.*

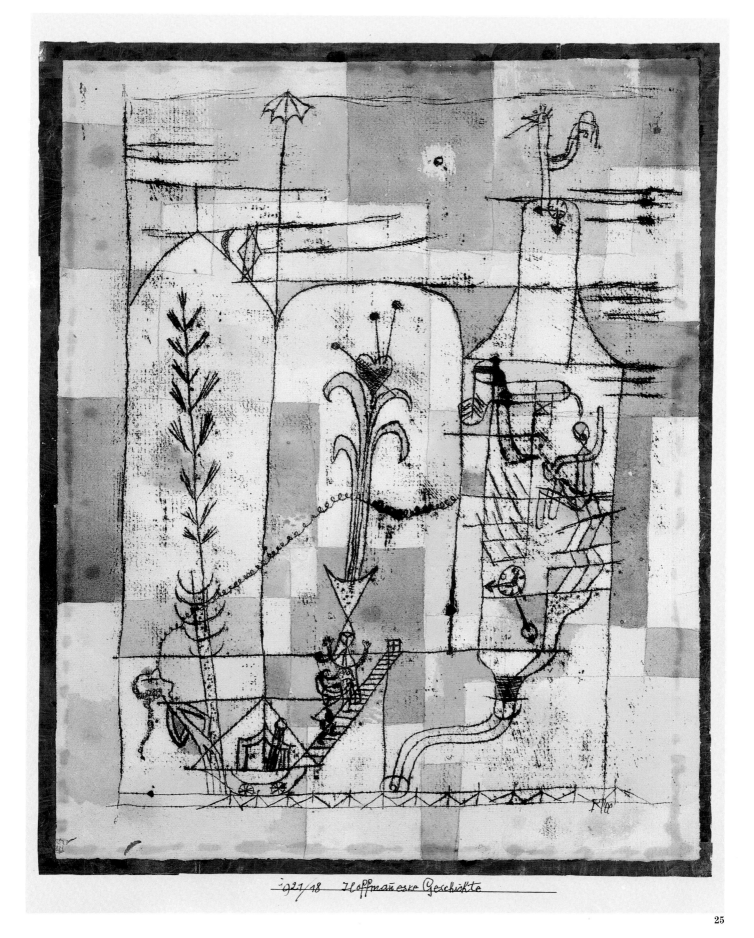

1921/18 Hoffmaneske Geschichte

25 A Hoffmannesque Tale, *1921. In Klee's early attempts to free painting from objective description, the linear patterns of the representational motifs and the color grid that organizes the pictorial surface coexist independently within the painting. In a sense, each constitutes a separate work.*

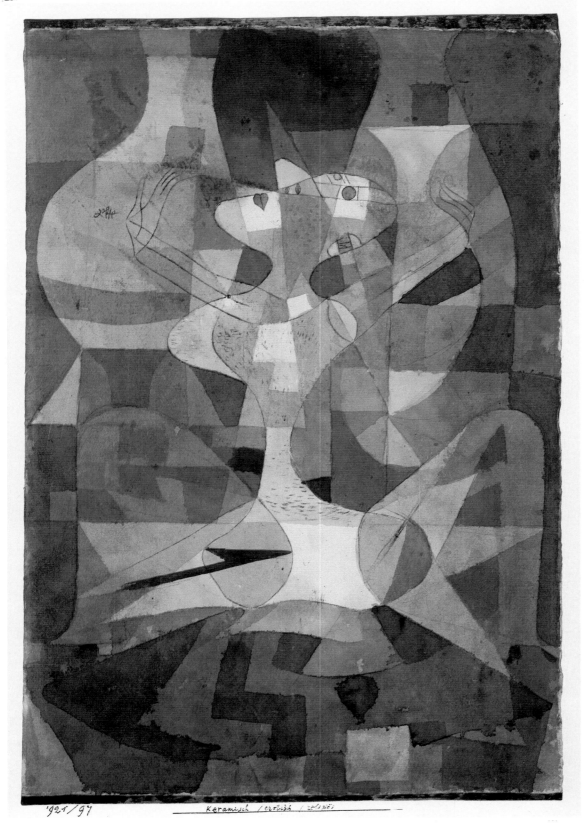

'1921/97 Keramisch /erotish / religiös

26 Aphrodite's Vases, or Ceramic/Erotic/Religious, *1921. The superimposition of several planes of green and cream suggests the shapes of ceramic vases on either side of Aphrodite's head. The goddess's figure emerges on the surface from this constructive process, in a manner reminiscent of certain Cubist images.*

27, 28 Architecture with a Window, *1919.* Ramparts with a Green Tower, *1919. In both of these paintings, architectural references serve as a metaphoric clarification of the image's construction. The influence of Robert Delaunay's well-known views of the Eiffel Tower, which express that structure as planes of color, is quite evident.*

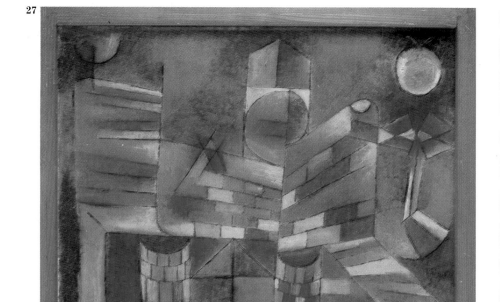

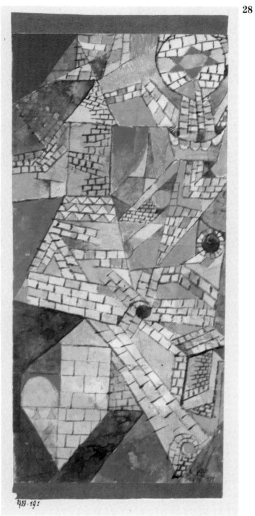

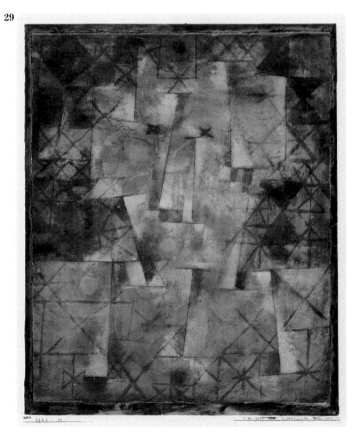

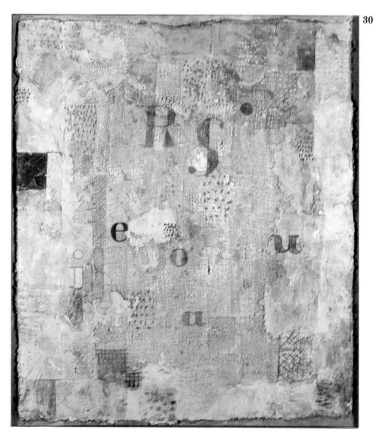

29 The God of the Northern Forest, *1922. Here we can see references to the Cubist paintings of Braque and Picasso of ten years earlier, although Klee has achieved a fuller formal unity than those artists did. In his painting, figure and background are no longer separate entities, but are fully integrated.*

30 The Costume of the Singer Rosa Silber, *1922. This work is painted on a length of muslin, which Klee has decorated with a mixture of plaster and paint.*

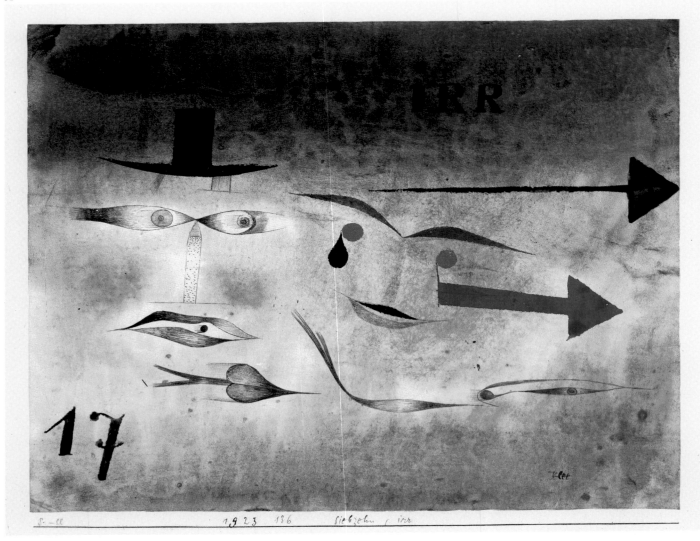

31 Seventeen, irr, *1923. This painting is organized in three bands. On the middle and brightest one are two enigmatic faces, which two arrows—a red one and a black one—seem to be pulling relentlessly to the right. This simple device enables Klee to fill the entire pictorial surface with tension, and to emphasize the contrasts between the two masklike faces.*

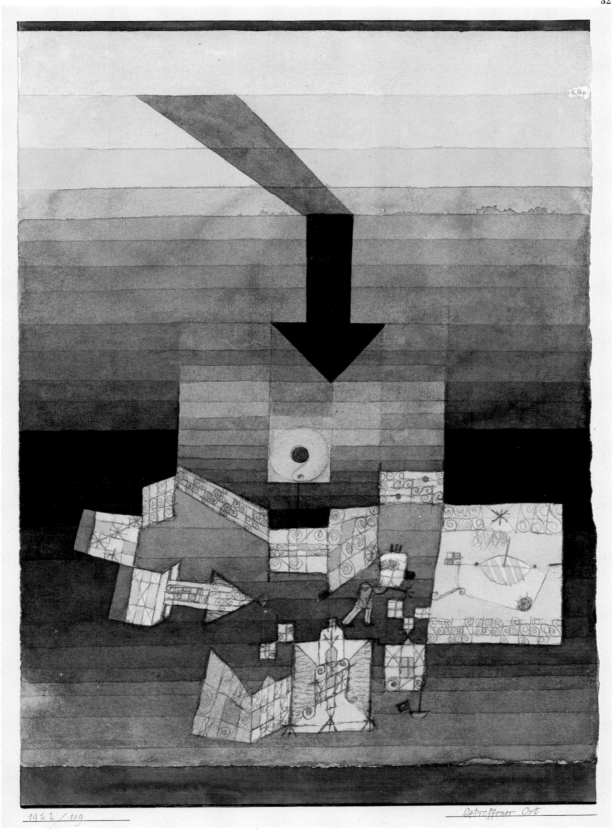

32 Affected Place, *1922. Here Klee has adopted the striped chromatic scale of the Swiss painter Johannes Itten, whom he met at the Bauhaus, and who had been a pupil of his father's many years before in Bern. For Klee, color had "weight" according to its degree of brilliance: dark tones were "heavy" and bright tones were "light." The black arrow in the upper register of the painting provides a counterweight to the dark bands of color in the lower field. These bands seem indeed to be bringing about the transformation of the place—a sort of imaginary garden—recorded in the title.*

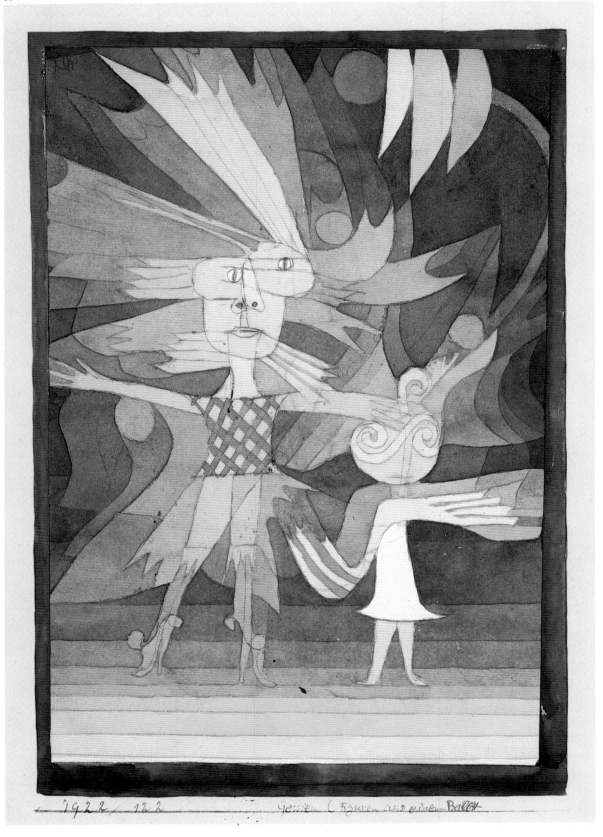

1922 / 122 Genien (Figuren aus einem Ballet

33 Genies (Figures from a Ballet), *1922. This painting may refer to the* Triadic Ballet *that Oskar Schlemmer mounted at the Bauhaus in 1922, in which movement and light were the main features. In any case, Klee's fascination with genies and ghosts is well known. The two figures seem to take a cue from the color bands at the bottom of the painting, which express the dance movement by echoing their limbs and features.*

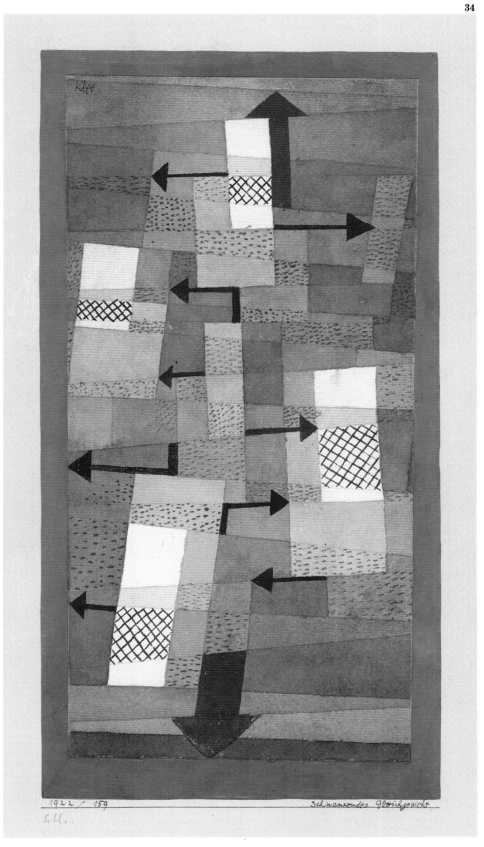

34 Wavering Balance, *1922. Here the pictorial surface is strained by the simultaneous action of opposing forces, expressed by arrows, whose contrary movement seems to distort the rectangular field.*

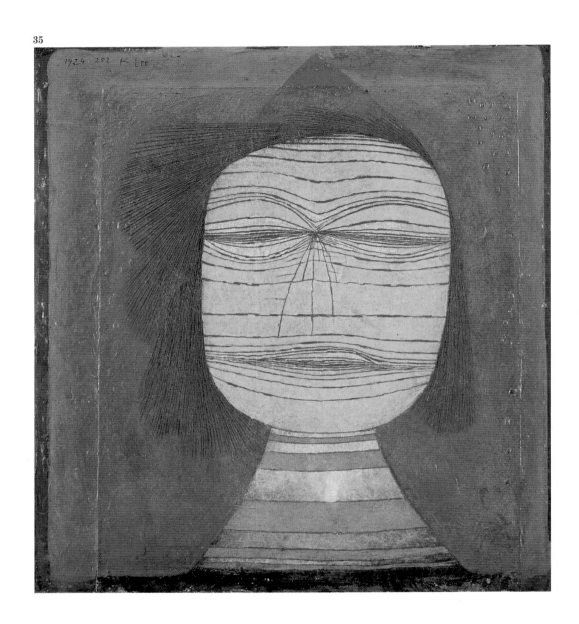

35 Actor's Mask, *1924. Klee applied his language of color bands and patterns to abstract surfaces and representational structures alike. Here, the face seems to be covered by a stretched wrapping that deforms the features, not unlike a head wrapped in an elastic stocking.*

36 Florentine Villas, *1926. On a thick primer, Klee has laid a network of colored squares, which he has then incised with a burin in repetitive graphic motifs, forming a series of ideogram-like façades. The result resembles an oriental carpet, whose flatness expresses a topological record of space.*

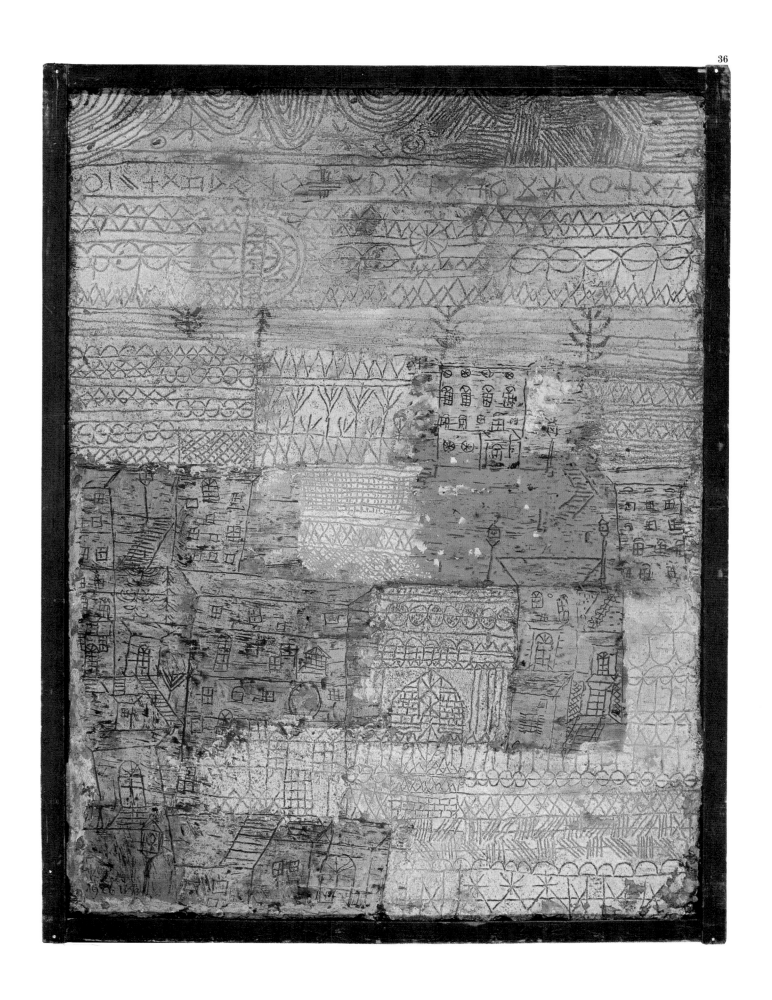

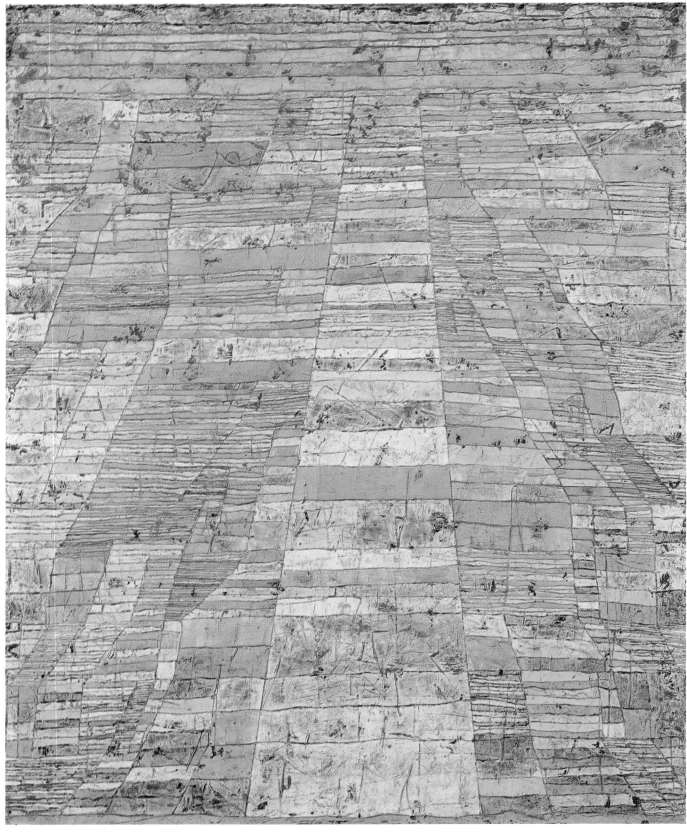

37 Main Road and Side Roads, *1929. The intersection of horizontal and vertical lines at different angles produces a network of uneven blocks, colored in various shades of gold and blue. These linear and flat elements suggest a view of a landscape stretching to the horizon, with the blue stripes at the top representing the sky.*

38 Polyphonic White, *1930. Here Klee exploits the ambiguities of perception, achieving a sensation of depth by combining a series of rectangles matched to the sequence of hues, with the lighter shades set closer to the center of the painting.*

1930 ≉18 polyphon gefasstes Weiss

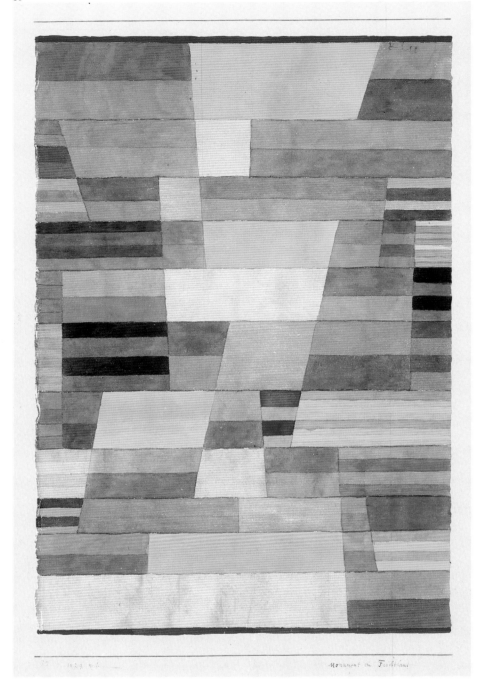

39 Monument in Fertile Ground, *1929. Color bands
of different lengths create the effect of spatial depth
by converging on a sort of horizon, slightly lower
than the center of the painting. The yellow bands, like
luminescent milestones, appear to mark out a path
through the painting.*

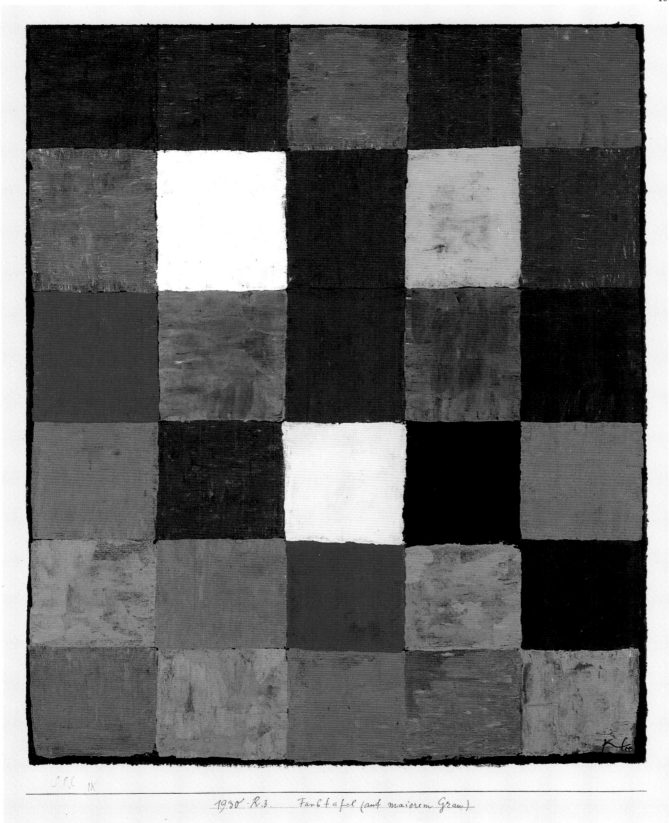

1930 · R.3. Farbtafel (auf maiorem Grau)

40 Color Board, *1930. The apparent regularity of the squares,
like checks on a chessboard, seems at odds with the lack of
demarcation lines between them. The juxtaposition of the colors
produces a vivid effect, which gives the surface the vibrant energy
of a flag rustling in the wind.*

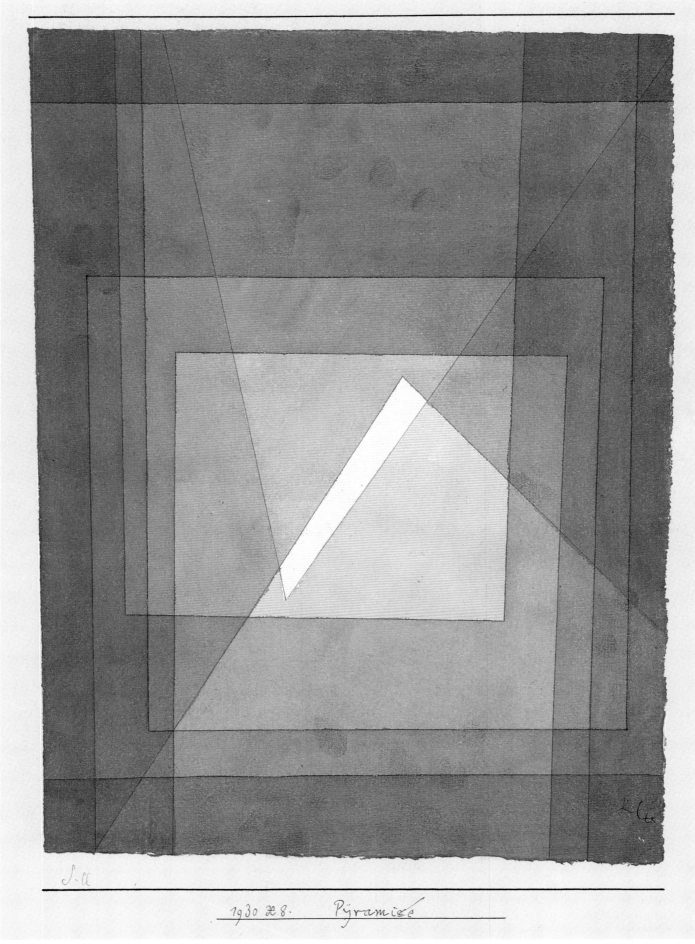

1930 æ8. Pyramide

41 Pyramid, *1930. As in* Polyphonic White, *the artist's aim is to evoke depth by combining geometry and graduated hues: the lighter the shade, the more distant it is from the edges of the painting. A series of diminishing squares intersects two opposing triangles, the lower one of which may be perceived as a pyramid silhouetted against the blue sky.*

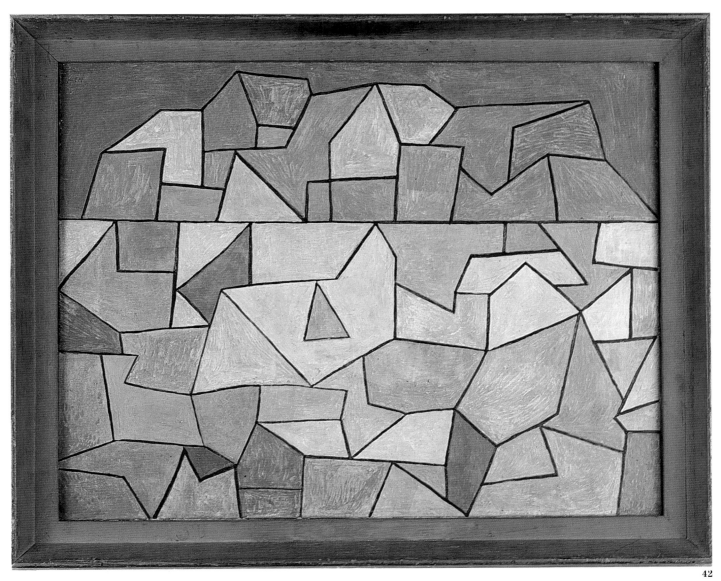

42 Village on Rocks, *1932. The subject is composed of various colored shapes. The form and direction of each brush stroke help to determine the manner in which each color cell operates in the surface.*

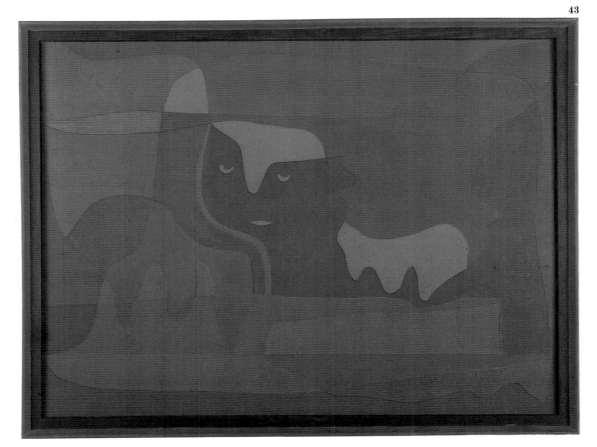

43 Sphinx at Rest, *1934. Klee constructed this painting by superimposing layers of color intersecting one another directly, with no lines to separate them. The effect is reminiscent of the paper cutouts that Matisse, in the last period of his work, was to create a decade later.*

44, 45 Blooming, *1934.* New Harmony, *1936. These are two characteristic examples of the color block paintings that Klee created during the last ten years of his life. The artist had often expressed the idea that a painting is a plane itinerary whose paths are determined by the weight, quality, and measure of lines and colors. The warped horizontal and vertical lines are designed to create tensions and to evoke spatial suggestions by rigorously formal means.*

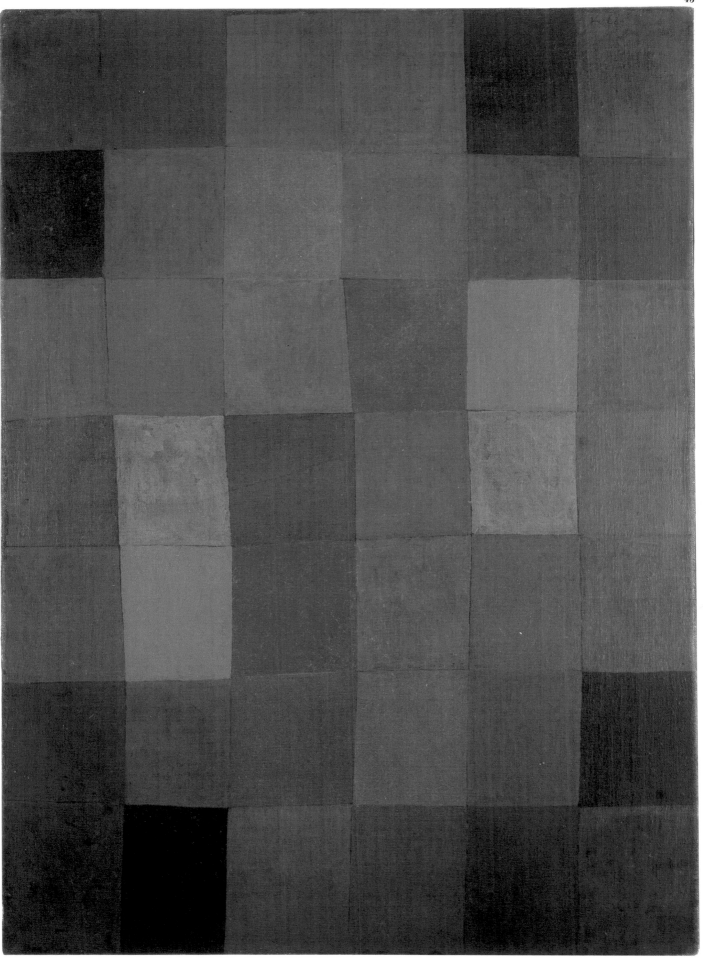
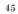

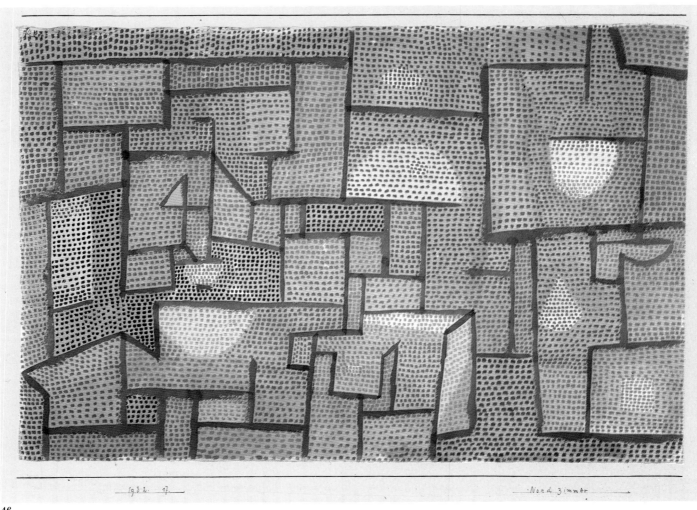

46

Mosaics of Color

In the first half of the 1930s, Klee's planes of softly blended colors began to give way in some paintings to forms composed of small, regular brush strokes, applied and juxtaposed with a pointillist technique. These touches of color appear in multiple variations: monochromatic strokes overlying a background of changeable color; parti-colored strokes against a homogeneous background; or highly complex compositions of colored strokes interacting with a colored background. Whatever the variation, the result, in contrast to Klee's earlier compositions in dilute watercolor, was a vibrant mosaic, densely loaded with shape and color. The new technique, however, did not fundamentally alter Klee's conceptions of painting; rather, it was an attempt to enlarge the possibilities of merging shape and color. Despite the presence of line in some of these works, the basic definition of form, trajectory, and directional tension on the surfaces is composed of contrasting color fields, built up of minute brush strokes.

46 Room with Northern Exposure, *1932.*
Klee organized this painting by outlining colored areas with thick black brush strokes, and then filling the marked-off spaces with tiny jots of color.

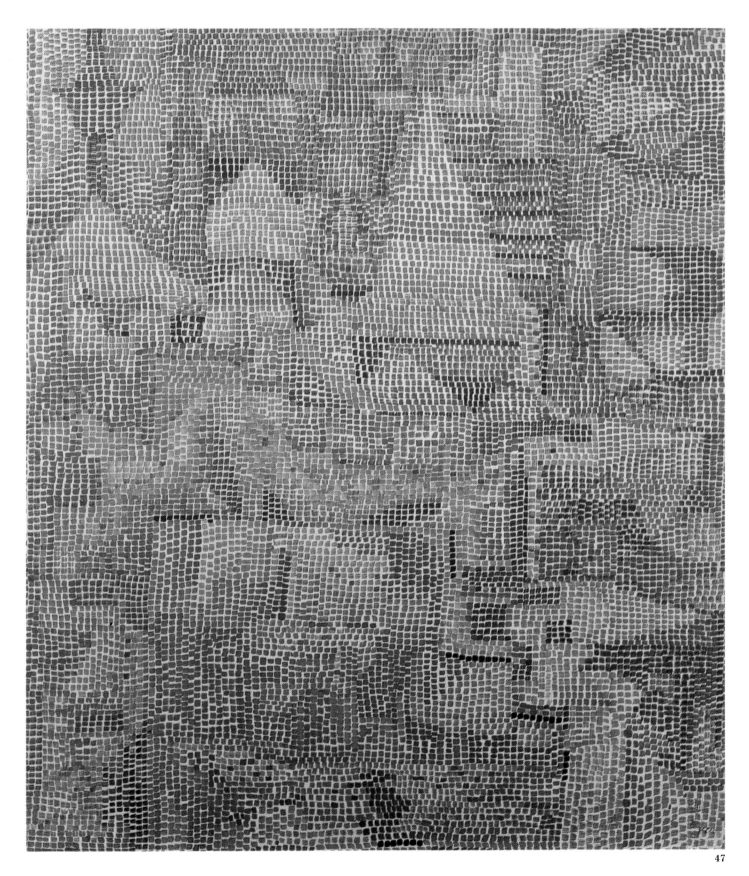

47 Castle Garden, *1931. Here Klee's regular, crowded brush strokes act as tesserae in a mosaic. The silhouettes of the castle and its surrounding garden merge on the same plane as the colors form a pattern. The lack of contour lines, however, makes it difficult to perceive immediately.*

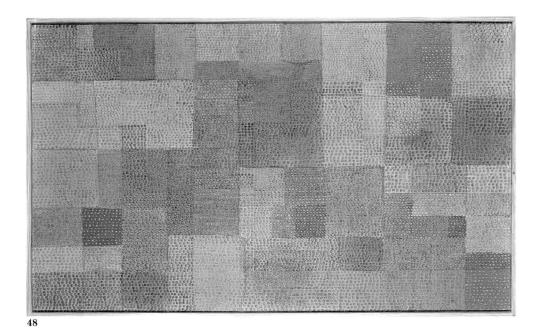

48

48 Polyphony, *1932. Here Klee plays with the chromatic contrasts between brush strokes and background colors. The title of the painting refers to the blending of the colors of the rectangles like the voices in a chorus.*

49 Ad Parnassum, *1932. A steady black stroke marks out the silhouette of the home of the muses, over an ocean of sparkling color. Only the sun, in the upper right corner, is expressed as a compact area of color.*

49

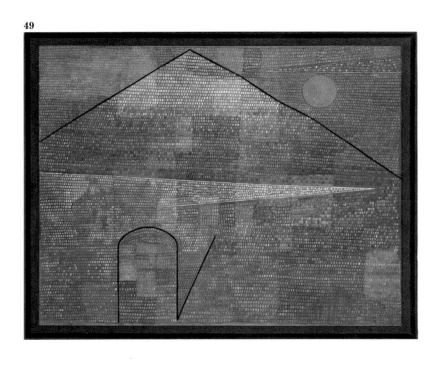

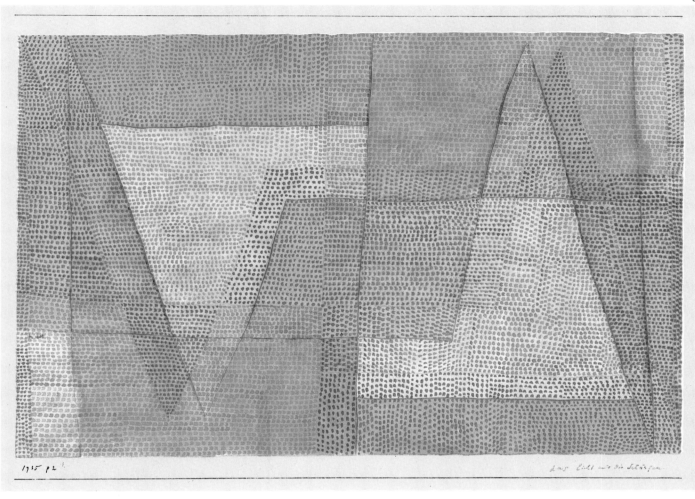

50 Light and Ridges, *1935. A geometric pattern of counterpoised rectangles and triangles is repeated, with a slight variation. While one set of shapes is carefully drawn with a line, it is echoed by a pattern made visible in the different hues of the brush strokes.*

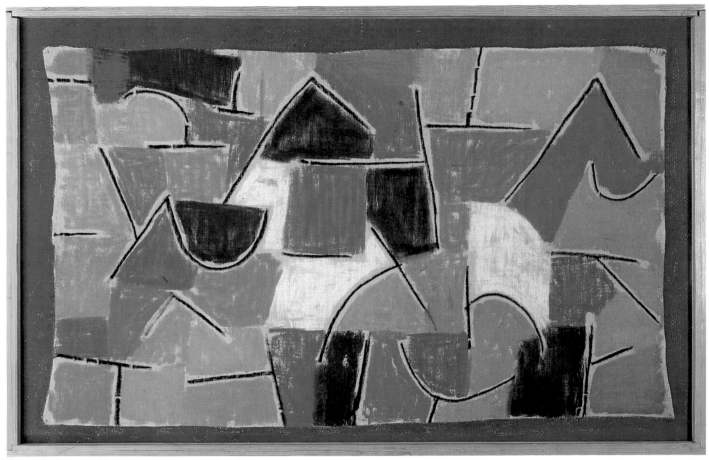

51

Labyrinths and Hieroglyphs

The last years of Klee's output were marked by an almost complete synthesis of the elements of his plastic system. The thick black strokes that organize his painted surfaces—against either a monochromatic background or outlining color planes—suggest the mystery of both the labyrinth and the Egyptian hieroglyph. Indeed, Klee was probably directly influenced by pharaonic inscriptions, many examples of which he saw carved on the stone walls of temples during a trip to Egypt in 1928. But beyond this, pictograms gave Klee a means to integrate in one single pictorial act both the graphic and the plastic elements of his art. The symbolic and antinaturalistic essence of these signs, combined with their formal regularity, must have satisfied Klee's desire for an abstract expression that retained its ties to nature. Thus, some of the properties traditionally reserved for representational art could find an entry into an art that the German painter always viewed as a mediating language between reality and the ideal universe of the imagination.

51 Blue Night, *1937. The areas of greatest tension in this painting result from a color pattern dominated by blues, emphasized by cream-colored lines. Their fragmented and curved shapes create a mazelike effect.*

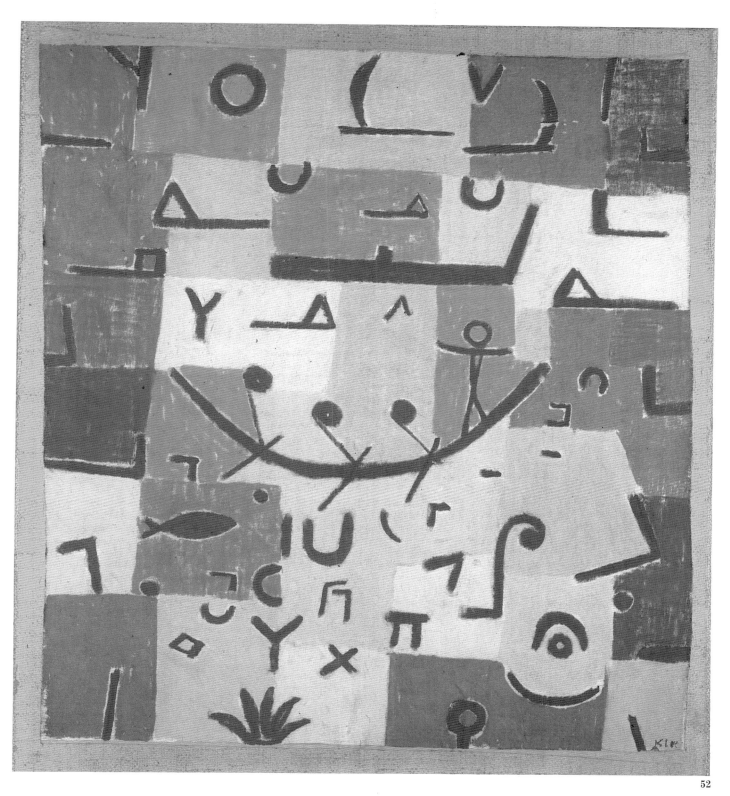

52 The Nile Legend, *1937. This painting is clearly a product of Klee's 1928 trip to Egypt. The pictograms, which allude to the Nile as well as to the farm work associated with it, are partly derived from hieroglyphs, and partly from objects depicted in Egyptian frescoes.*

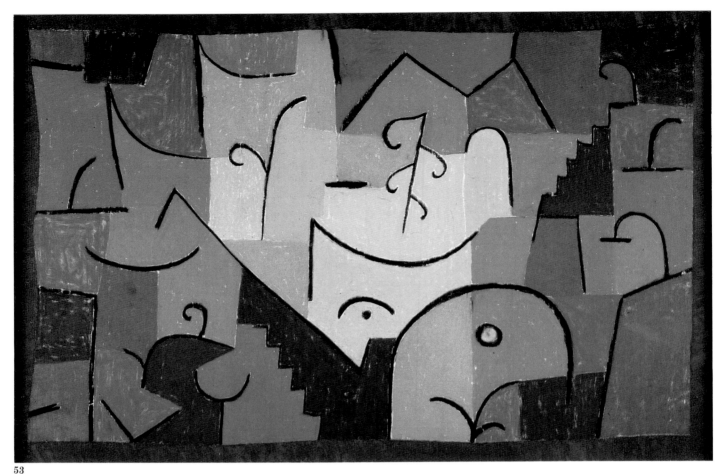

53

53, 54 Stage Landscape, *1937.* Harmonized Battle, *1937. As far as their formal structure is concerned, both of these labyrinth paintings are similar to* Blue Night. *The prevailing idea is that of a chromatic harmony resulting from the seeming arbitrariness of the black lines. The second work is a clear example of the synthesis of representational contents and pictorial structure that Klee tried to achieve through the use of pictograms.*

54

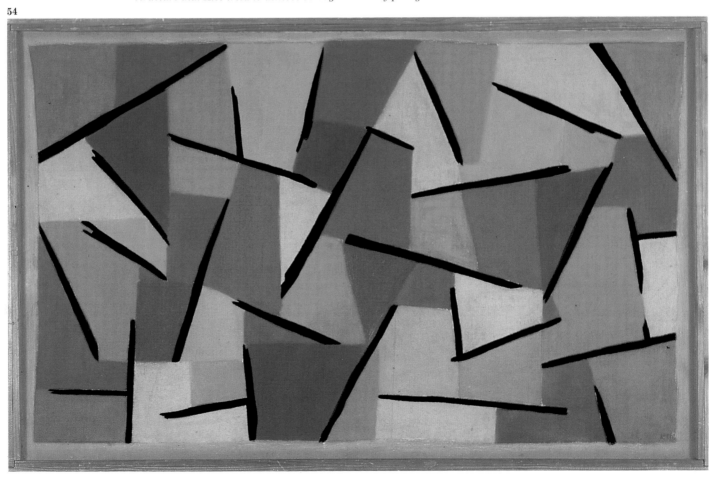

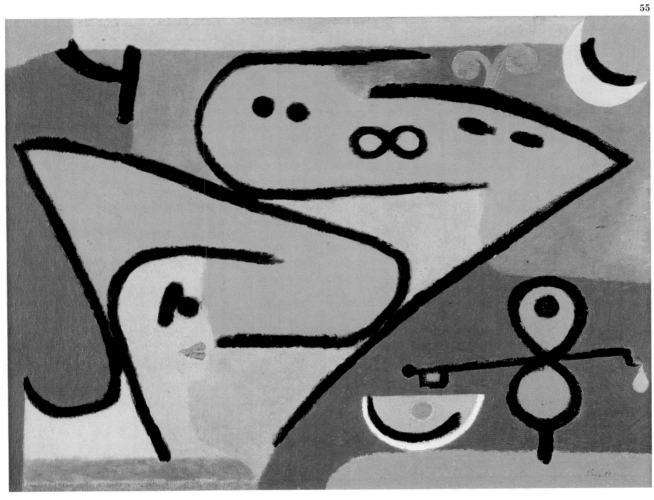

55 Aeolian, *1938. The stretching of the shapes here seems to be related to the movement of the wind, as suggested by the title. The two folded brown elements are reminiscent of a 1903 etching entitled* Two Men Arguing over Who Holds the Higher Position.

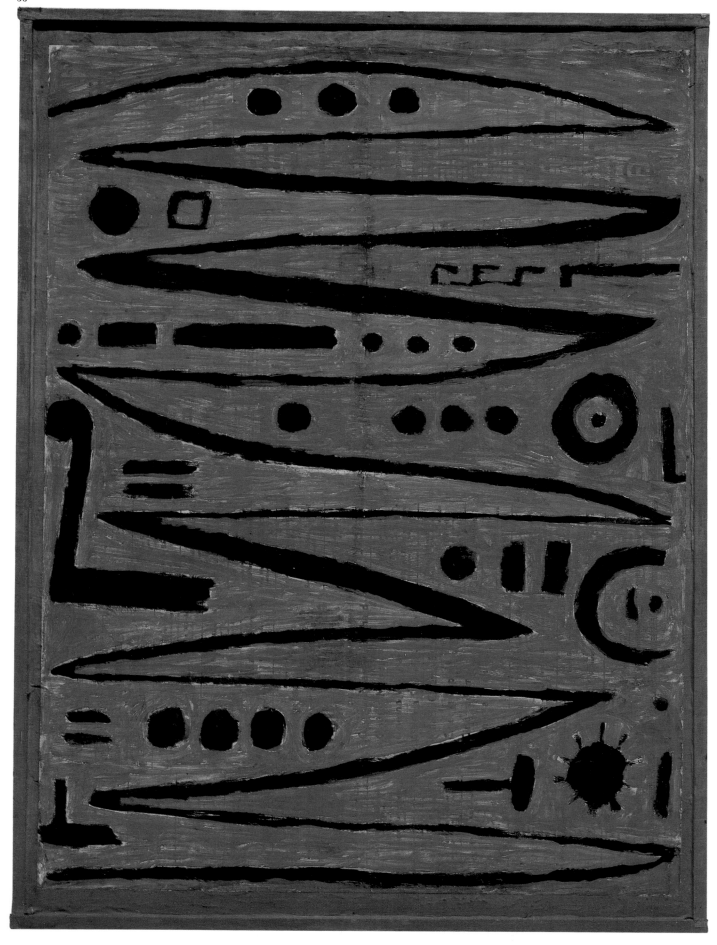

56 Heroic Strokes of the Bow, *1938. This picture is in effect a large pictogram. The successive sweeps of the primary zigzag represent the strokes of a violin bow, while the smaller signs allude to the sun and the moon.*

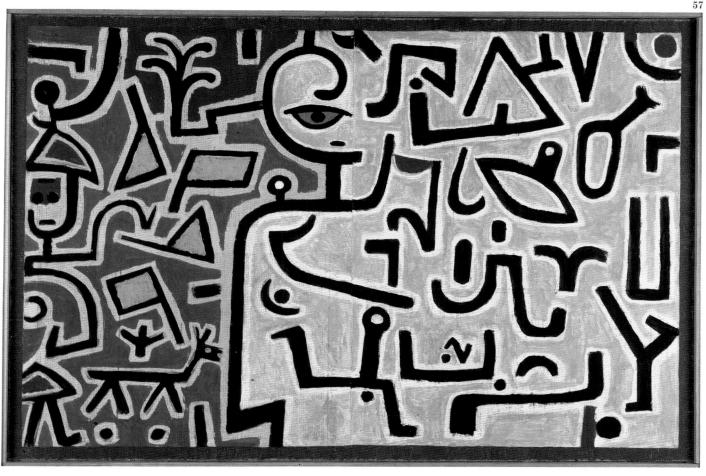

57 Intention, *1938. A human figure divides this painting in two. Small pictograms, representing characters and objects, enliven the pictorial surface of each division of the painting with a swarm of marks set against a monochromatic background.*

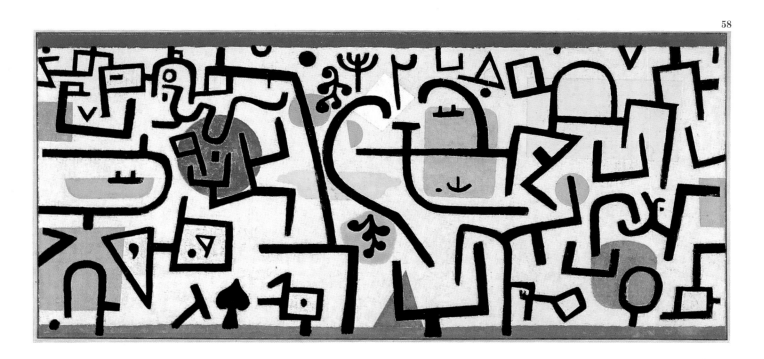

58 Rich Harbor, *1938. In his last years, Klee kept returning to paintings in which a multitude of shapes—often pictograms—coexist, establishing every type of relation among themselves, while preserving their own individuality. Here we see Klee's crammed vision of the hustle and bustle of a port.*

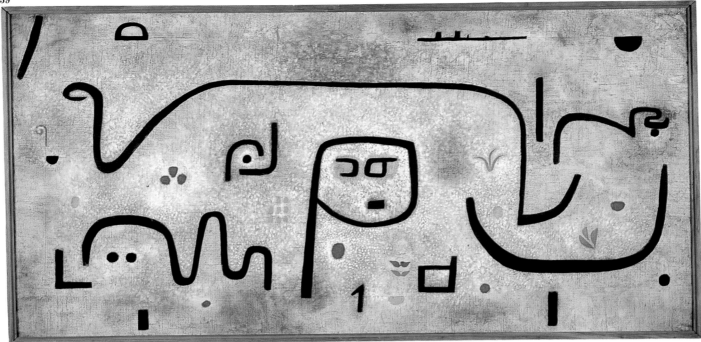

59 Insula Dulcamara, *1938. The ambiguity of the sentiments that must have overwhelmed Klee in the last years of his struggle against his disease is rendered in the bittersweet tone to which the title of this painting alludes. Different shapes are scattered over a gauzy background of pinks, greens, and blues. The benign aura of the color contrasts with the sad demeanor of the schematic face in the center.*

60 Park near Lu(cerne), *1938. The trees here are reduced to rhythmic marks outlined in various colors, while a suggestion of parklike green appears behind them.*

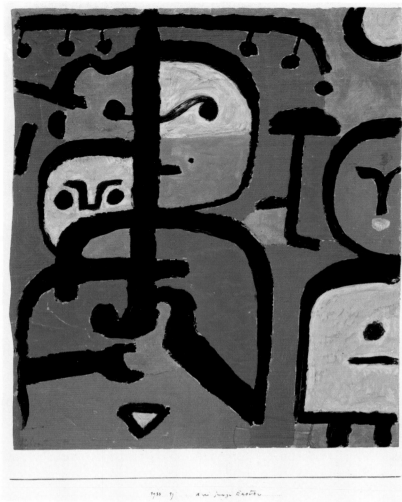

61 Three Exotic Youths, *1938. The idea of a character that does not fit the mold, that even rejects it, is a recurrent theme in Klee's late work.*

62 Earth Witches, *1938. This is one of the last of Klee's paintings of ghosts and other fantastic beings, expressed in a somber palette befitting this tragic point in his life*

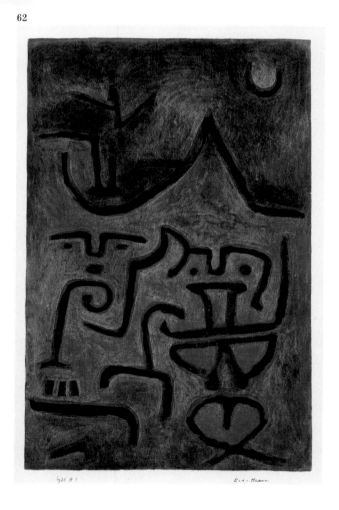

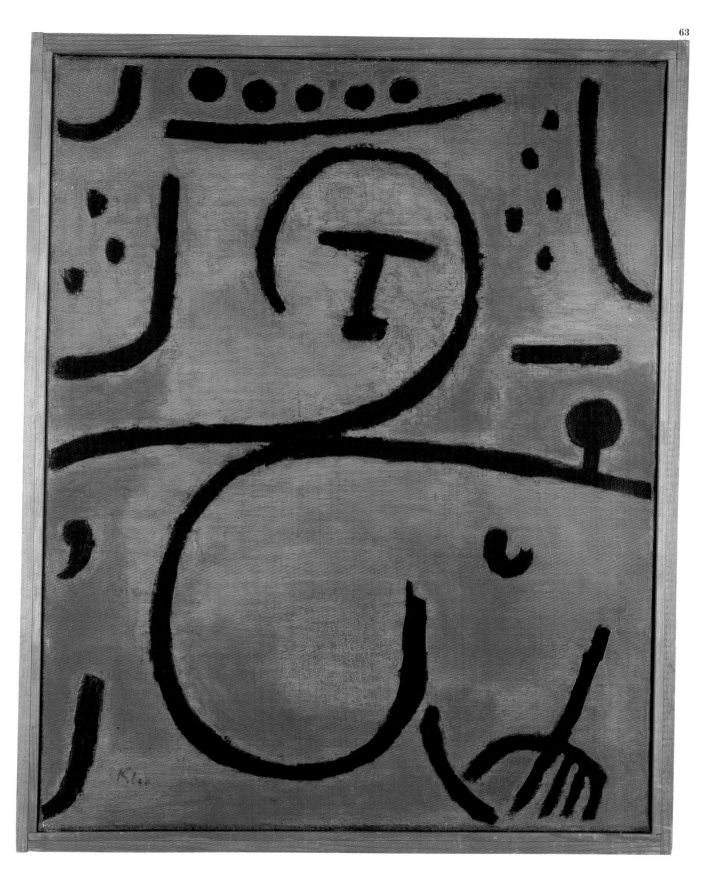

63 Decadent Pomona (Slightly Reclined), *1938. The simple power of this figure, a mere graphic gesture reduced to its essentials, is reminiscent of some of Joan Miró's last works. Although the title alludes to an antique earth and fertility goddess, it is almost impossible not to associate the mysterious figures in Klee's last paintings with his coming death.*

List of Plates

1 In the Quarry, *1913. Watercolor on paper, mounted on cardboard, 8¾ × 13¹³⁄₁₆" (22.3 × 35.2 cm). Klee Foundation, Kunstmuseum, Bern.*

2 Houses near Stony Ground (Sketch), *1913. Watercolor on paper, mounted on cardboard, 6⅛ × 6½" (15.6 × 16.7 cm). Klee Foundation, Kunstmuseum, Bern.*

3 Quarry at Ostermundigen: Two Cranes, *1907. Charcoal, India ink, and watercolor on paper, mounted on cardboard, 24¹³⁄₁₆ × 19⅛" (63.1 × 48.6 cm). Klee Foundation, Kunstmuseum, Bern.*

4 Before the Gates of Kairouan, *1914. Watercolor on paper, mounted on cardboard, 8 × 12⅜" (20.7 × 31.5 cm). Klee Foundation, Kunstmuseum, Bern.*

5 Hammamet Motif, *1914. Watercolor on paper, mounted on cardboard, 8 × 6⅛" (20.2 × 15.7 cm). Öffentliche Kunstsammlung Basel, Kunstmuseum.*

6 Saint-Germain, near Tunis, *1914. Watercolor on paper, mounted on cardboard, 8½ × 12¼" (21.6 × 32.4 cm). Musée National d'Art Moderne, Paris.*

7 Quarry at Ostermundigen, *1915. Watercolor on paper, mounted on cardboard, 8 × 9¾" (20.2 × 24.6 cm). Klee Foundation, Kunstmuseum, Bern.*

8 Suddenly from the Gray of Night…, *1918. Watercolor on paper, mounted on cardboard, 8⅞ × 9¾" (22.6 × 24.6 cm). Klee Foundation, Kunstmuseum, Bern.*

9 Bird Islands, *1921. Watercolor and oil on paper, mounted on cardboard, 12⅛ × 18" (30.8 × 45.8 cm). Klee Foundation, Kunstmuseum, Bern.*

10 Genie Serving a Light Breakfast, *1920. Lithograph, 7¾ × 5¾" (19.8 × 14.6 cm). Sprengel Museum, Hanover.*

11 Castle in the Air, *1922. Oil and watercolor on plastered gauze, mounted on cardboard, 24⅝ × 16" (62.6 × 40.7 cm). Kunstmuseum, Bern. Foundation Hermann and Margrit Rupf.*

12 Analysis of Various Perversities, *1922. Watercolor and India ink on paper, mounted on cardboard, 12¼ × 9½" (31 × 24 cm). Musée National d'Art Moderne, Paris.*

13 Twittering Machine, *1922. Watercolor and ink on oil transfer drawing on paper, mounted on cardboard, 25¼ × 19" (63.8 × 48.1 cm). The Museum of Modern Art, New York.*

14 Ventriloquist and Crier on the Moor, *1923. Watercolor and printer's ink on paper, mounted on cardboard, 15¼ × 11" (38.7 × 27.9 cm). The Metropolitan Museum of Art, New York. The Berggruen Klee Collection.*

15 Tightrope Walker, *1923. Watercolor, oil, pencil, and India ink on paper, mounted on cardboard, 19⅛ × 12⅝" (48.7 × 32.2 cm). Klee Foundation, Kunstmuseum, Bern.*

16 Portrait of an Acrobat, *1927. Watercolor and collage on cardboard, mounted on panel, 24⅞ × 15¾" (63.2 × 40 cm). The Museum of Modern Art, New York. Mrs. Simon Guggenheim Fund.*

17 Mask with Banderole, *1925. Watercolor on paper, mounted on cardboard, 25⅝ × 19½" (65 × 49.5 cm). Staatsgalerie, Munich.*

18 Cat and Bird, *1928. Oil and ink on canvas, mounted on panel, 15 × 21" (38.1 × 53.2 cm). The Museum of Modern Art, New York. Sydney and Harriet Janis Collection Fund and gift of Suzy Prudden and Joan H. Meijer in memory of F.H. Hirschland.*

19 Mask of Fear, *1932. Oil on burlap, 39½ × 22½" (100.3 × 57.1 cm). The Museum of Modern Art, New York. Nelson A. Rockefeller Fund.*

20 Oath of Ghosts, *1930. Watercolor and red chalk on paper, mounted on cardboard, 18½ × 14⅞" (47.1 × 37.8 cm). Klee Foundation, Kunstmuseum, Bern.*

21 In the Margin, *1930. Watercolor and India ink on plastered gauze, mounted on cardboard, 17⅛ × 13" (43.5 × 33 cm). Öffentliche Kunstsammlung Basel, Kunstmuseum.*

22 Shelter for Four, *1939. Oil and watercolor on paper, mounted on cardboard, 12⅜ × 18⅞" (31.5 × 48 cm). Klee Foundation, Kunstmuseum, Bern.*

23 Untitled, *c. 1940. Black paste color on paper, mounted on cardboard, 11½ × 11¾" (29.4 × 30.1 cm). Klee Foundation, Kunstmuseum, Bern.*

24 Station L 112, 14 km., *1920. Watercolor and India ink on paper, mounted on cardboard, 4⅞ × 8⅝" (12.3 × 21.8 cm). Kunstmuseum, Bern. Foundation Hermann and Margrit Rupf.*

25 A Hoffmannesque Tale, *1921. Watercolor on paper, mounted on cardboard, 12¼ × 9½" (31.1 × 24.1 cm). The Metropolitan Museum of Art, New York. The Berggruen Klee Collection.*

26 Aphrodite's Vases, or Ceramic/Erotic/Religious, *1921. Watercolor on paper, mounted on cardboard, 18¼ × 11¾" (46.3 × 30.1 cm). Klee Foundation, Kunstmuseum, Bern.*

27 Architecture with a Window, *1919. Oil and India ink on paper, mounted on panel, 19⅝ × 16⁵⁄₁₆" (50 × 41.5 cm). Klee Foundation, Kunstmuseum, Bern.*

28 Ramparts with a Green Tower, *1919. Watercolor and gouache on paper, mounted on cardboard, 11⅞ × 5⅛" (30.3 × 13 cm). Klee Foundation, Kunstmuseum, Bern.*

29 The God of the Northern Forest, *1922. Oil and India ink on canvas, mounted on cardboard, 21¹⁄₁₆ × 16¼" (53.5 × 41.4 cm). Klee Foundation, Kunstmuseum, Bern.*

30 The Costume of the Singer Rosa Silber, *1922. Watercolor and plaster on muslin, mounted on cardboard, 24½ × 20½" (62.3 × 52.1 cm). The Metropolitan Museum of Art, New York. Gift of Mr. and Mrs. Stanley Resor.*

31 Seventeen, irr, *1923. Watercolor and India ink on paper, mounted on cardboard, 8¾ × 11¼" (22.5 × 28.5 cm). Öffentliche Kunstsammlung Basel, Kunstmuseum.*

32 Affected Place, *1922. Watercolor, India ink, and pencil on paper, mounted on cardboard, 12⅞ × 9⅛" (32.8 × 23.1 cm). Klee Foundation, Kunstmuseum, Bern.*

33 Genies (Figures from a Ballet), *1922. Watercolor and pencil on paper, mounted on cardboard, 10⅛ × 6⅞" (25.7 × 17.4 cm). Klee Foundation, Kunstmuseum, Bern.*

34 Wavering Balance, *1922. Watercolor and pencil on paper, mounted on cardboard, 13⁹⁄₁₆ × 7" (34.5 × 17.8 cm). Klee Foundation, Kunstmuseum, Bern.*

35 Actor's Mask, *1924. Oil on canvas, mounted on panel, 14⁷⁄₁₆ × 13⅛" (36.7 × 33.8 cm). The Museum of Modern Art, New York. The Sydney and Harriet Janis Collection.*

36 Florentine Villas, *1926. Oil on canvas, 19½ × 14¾" (49.5 × 36.5 cm). Musée National d'Art Moderne, Centre Georges Pompidou, Paris.*

37 Main Road and Side Roads, *1929. Oil on canvas, 33 × 26½" (83.7 × 67.5 cm). Museum Ludwig, Cologne.*

38 Polyphonic White, *1930. Watercolor and India ink on paper, mounted on cardboard, 13⅛ × 9⅝" (33.3 × 24.5 cm). Klee Foundation, Kunstmuseum, Bern.*

39 Monument in Fertile Ground, *1929. Watercolor on paper, mounted on cardboard, 18 × 12⅛" (45.7 × 30.8 cm). Klee Foundation, Kunstmuseum, Bern.*

40 Color Board, *1930. Pastel on cardboard, 14⅞ × 12" (37.7 × 30.4 cm). Klee Foundation, Kunstmuseum, Bern.*

41 Pyramid, *1930. Watercolor and India ink on paper, mounted on cardboard, 12¼ × 9⅛" (31.2 × 23.2 cm). Klee Foundation, Kunstmuseum, Bern.*

42 Village on Rocks, *1932. Oil on canvas, 17½ × 22¼" (44.5 × 56.5 cm). Klee Foundation, Kunstmuseum, Bern.*

43 Sphinx at Rest, *1934. Oil on canvas, 35½ × 47¼" (90 × 120 cm). Klee Foundation, Kunstmuseum, Bern.*

44 Blooming, *1934. Oil on canvas, 31⅞ × 31½" (81 × 80 cm). Kunstmuseum, Winterthur.*

45 New Harmony, *1936. Oil on canvas, 37 × 26" (94 × 66 cm). The Solomon R. Guggenheim Museum, New York.*

46 Room with Northern Exposure, *1932. Watercolor on paper, mounted on cardboard, 14½ × 21⅝" (37 × 55 cm). Klee Foundation, Kunstmuseum, Bern.*

47 Castle Garden, *1931. Oil on canvas, 26½ × 21⅝" (67.2 × 54.9 cm). The Museum of Modern Art, New York. The Sydney and Harriet Janis Collection Fund.*

48 Polyphony, *1932. Oil on canvas, 41¾ × 26⅛" (106 × 66.5 cm). Foundation Emanuel Hoffmann, Kunstmuseum Basel.*

49 Ad Parnassum, *1932. Oil on canvas, 39⅜ × 49⅝" (100 × 126 cm). Klee Foundation, Kunstmuseum, Bern.*

50 Light and Ridges, *1935. Watercolor on paper, mounted on cardboard, 12½ × 18⅞" (32 × 48 cm). Klee Foundation, Kunstmuseum, Bern.*

51 Blue Night, *1937. Gouache on cotton canvas, mounted on burlap, 19¾ × 30" (50.3 × 76.4 cm). Öffentliche Kunstsammlung Basel, Kunstmuseum.*

52 The Nile Legend, *1937. Pastel on cotton canvas, mounted on burlap, 27⅛ × 24" (69 × 61 cm). Kunstmuseum, Bern. Foundation Hermann and Margrit Rupf.*

53 Stage Landscape, *1937. Pastel on cotton canvas, mounted on burlap, 23½ × 38⅞" (58.5 × 86 cm). Kunstmuseum, Bern. Foundation Hermann and Margrit Rupf.*

54 Harmonized Battle, *1937. Pastel on cotton canvas, mounted on burlap, 22½ × 33⅞" (57 × 86 cm). Klee Foundation, Kunstmuseum, Bern.*

55 Aeolian, *1938. Oil on newsprint, mounted on burlap, 20½ × 26¾" (52 × 68 cm). Kunstmuseum, Bern. Foundation Hermann and Margrit Rupf.*

56 Heroic Strokes of the Bow, *1938. Colored paste on newspaper, mounted on dyed cotton fabric, 28¾ × 20⅞" (73 × 52.7 cm). The Museum of Modern Art, New York. Nelson A. Rockefeller Bequest.*

57 Intention, *1938. Paste colors on newsprint, mounted on burlap, 29½ × 44⅛" (75 × 112 cm). Klee Foundation, Kunstmuseum, Bern.*

58 Rich Harbor, *1938. Tempera on paper, mounted on canvas, 29¾ × 65" (75.5 × 165 cm). Öffentliche Kunstsammlung Basel, Kunstmuseum.*

59 Insula Dulcamara, *1938. Oil on newsprint, mounted on burlap, 34⅜ × 69¼" (88 × 176 cm). Klee Foundation, Kunstmuseum, Bern.*

60 Park near Lu(cerne), *1938. Oil on newsprint, mounted on burlap, 39⅜ × 27½" (100 × 70 cm). Klee Foundation, Kunstmuseum, Bern.*

61 Three Exotic Youths, *1938. Paste colors on paper, mounted on cardboard, 18¼ × 15⅝" (46.6 × 39.8 cm). Klee Foundation, Kunstmuseum, Bern.*

62 Earth Witches, *1938. Watercolor and oil varnishing on paper, mounted on cardboard, 19⅛ × 12½" (48.5 × 31.2 cm). Klee Foundation, Kunstmuseum, Bern.*

63 Decadent Pomona (Slightly Reclined), *1938. Oil on newsprint, mounted on cardboard, 26¾ × 19¾" (68 × 50 cm). Klee Foundation, Kunstmuseum, Bern.*

Selected Bibliography

Will Grohmann, *Klee*, Cercle d'Art, Paris, 1991.
Enric Jardí, *Paul Klee*, Ediciones Polígrafa, Barcelona, 1990.
Pierre Courthion, *Paul Klee*, Paris, 1953.
Herbert Read, *Klee*, London, 1984.

Series Coordinator, English-language edition: Ellen Rosefsky Cohen
Editor, English-language edition: Elaine M. Stainton
Designer, English-language edition: Judith Michael

Library of Congress Catalog Card Number: 95–78426
ISBN 0–8109–4676–9

Published in 1996 by Harry N. Abrams, Incorporated, New York
A Times Mirror Company

Printed and bound in Spain by La Polígrafa, S.L.
Parets del Vallès (Barcelona)
Dep. Leg.: B.43.755-1995